T0287418

LLANDUDNO'S MILITARY HERITAGE

Peter Johnson & Adrian Hughes

AMBERLEY

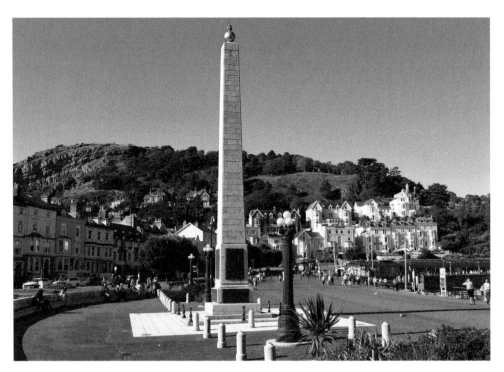

Llandudno's war memorial.

To all those who did not return home to Llandudno, 'Betwixt the Ormes'

First published 2020

Amberley Publishing
The Hill, Stroud
Gloucestershire, GL5 4EP

www.amberley-books.com

Copyright © Peter Johnson and
Adrian Hughes, 2020

Logo source material courtesy of Gerry van Tonder

The right of Peter Johnson and Adrian Hughes to
be identified as the Authors of this work has been
asserted in accordance with the Copyrights, Designs
and Patents Act 1988.

ISBN 978 1 4456 9818 2 (print)
ISBN 978 1 4456 9819 9 (ebook)

All rights reserved. No part of this book may be
reprinted or reproduced or utilised in any form
or by any electronic, mechanical or other means,
now known or hereafter invented, including
photocopying and recording, or in any information
storage or retrieval system, without the permission
in writing from the Publishers.

British Library Cataloguing in Publication Data.
A catalogue record for this book is available from the
British Library.

Origination by Amberley Publishing.
Printed in Great Britain.

Introduction

Given the grotesque loss of life and devastation that war and other conflicts cause, it might seem peculiar that the human species has indulged in these pursuits since time immemorial. In the 1960s academics debated whether Europe had had any year that did not witness a war within its borders over the previous 3,000 or so years. Some estimates claimed there may have been around 250 years of peace, though these appear not to have taken into account many small and local skirmishes. The safe conclusion is that hostilities were causing mayhem somewhere, whatever year may be picked at random, which partly explains why battles, wars and invasions feature so prominently in historical studies.

Away from the headlines of history, the circumstances of local communities often go unreported. Yet their populations also can be directly involved in tragic encounters, usually through invasion or by aggressive hit-and-run raiders. At other times they may be immersed in a war effort for military engagements taking place far from home. A third scenario involves clashes within a society, in civil wars and, for example, between adherents of differing religious beliefs. It is on these local perspectives and the individuals caught up in these events that *Llandudno's Military Heritage* focuses.

The first part surveys the period from antiquity up to the nineteenth century and takes as its region of interest the northern reaches of the Creuddyn Peninsula. This embraces the present-day urban areas and associated rural hinterlands of Llandudno, Craig-y-Don, Penrhyn Bay, then across to Deganwy and West Shore. Evidence for much of this period is limited and conclusions drawn from it are often tentative, though sufficient can be established to give an intriguing portrayal of the area. In the second part the emphasis centres on the resort town of Llandudno and reflects on its involvement in military activity during the twentieth century up until the Second World War. Later conflicts, and those presently engaged in, would fit uneasily into a book detailing heritage and history.

Though the atrocities of conflict should never be forgotten, the work, acts and often unsung bravery of local people at home, at sea, in the air and on foreign fields are recounted in these pages.

Llandudno's Military Heritage

Prehistory

In Wales the Neolithic (New Stone Age) was established around 3500 BC, bringing with it a settled way of life centred on rudimentary agriculture. It was once thought that these were peaceful times, yet recent scholarship advises that skeletal evidence displays injuries consistent with acts of violence, signs such as skull-trauma indicating an assault at close range and, tellingly, flint arrowheads embedded in bone. Whether these acts could be considered as war, or befell individuals engaged in feuds, or had transgressed either social or territorial boundaries, is not clear. No suggestion of conflict from the few remains discovered has been noted for the Creuddyn. Nevertheless, monumental architecture from this period, such as Lletty'r Filiast, a small portal dolmen on the Great Orme dating between 3000 and 2000 BC, were likely to have served as boundary markers – which implies that some outsiders might have wished to ignore land ownership claims, provoking violence as a consequence.

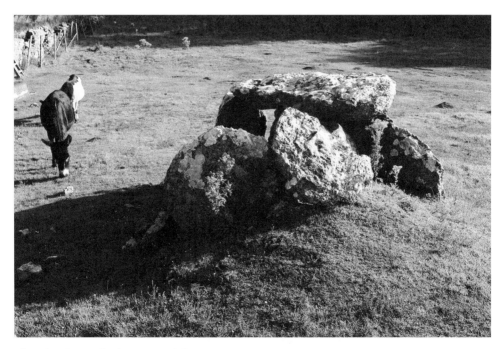

Lletty'r Filiast – built in peaceful times?

The introduction of bronze and metallurgy was a major advance in materials technology. There were also developments in weaponry; for the first time swords could be fashioned, a novel instrument of killing that would transform personal combat. The new technology reached Wales around 2200 BC. Its main manifestation in the Creuddyn appeared around two hundred years later with the beginning of opencast copper mining on the Great Orme. This now famous site was probably mined extensively between *c.* 1600 and 1400 BC and then intermittently and as the seasons allowed until around 800 BC. The most recognisable artefacts produced from this mine's copper are bronze axe heads. Although manufactured for agricultural purposes and to signal social and ceremonial status their potential value as weapons cannot be underestimated. It has been suggested that on a Europe-wide basis controlling the extended networks to obtain copper or tin and to distribute the finished products encouraged the growth of complex, hierarchical societies dominated by a warrior elite. As with the preceding period, there is no evidence for any armed engagements on the Great Orme, yet with such a valuable resource, one known across Britain and on to the Continent, we might not be surprised should signs of conflict be discovered. One mystery regarding this site is where did the miners live? No settlement for them has been located; if one is revealed then the picture of how they lived and what challenges they faced may become clearer.

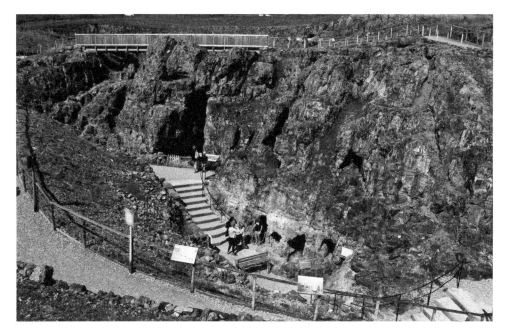

As surface workings of the extensive copper mines on the Great Orme became depleted, miners tunnelled down into the ore-bearing rock. The visitors stand at the lower level of the opencast, outside one of the shaft entrances. (Courtesy of Great Orme Mines Ltd)

Towards the end of the Bronze Age upland sites were abandoned. It was long considered that a deteriorating climate underlay this but it now seems more likely that earlier social and economic shifts played the determining role, one that was later augmented by climate change. Across the country indications of wooden palisades surrounding settlements begin to appear, probably because those dispossessed of agricultural land sought to displace those who were still successfully farming.

The Iron Age did not develop overnight from the Bronze Age, though fundamental changes were to impose themselves after 600 BC. An early development followed trends set in the late Bronze Age: the fortification of some settlements. These now lay behind defensive stone walls, ditches and earthen embankments, such as are found at Pen Dinas on the Great Orme. Hill forts were once thought to have been built solely for defensive purposes – the Iron Age Celts were believed to have been a ferocious bunch, forever willing to raid, pillage and do battle, whether on foot or horseback – but it now seems more likely that the forts had additional functions that may signal a shift in the culture's values. Some were probably centres where extended families met on auspicious occasions, to celebrate rituals, and for markets. What is clear is that alliances were being formed. The time and resources involved in building the hill forts alone signals this. By peaceful means or otherwise these groups merged to become members of the Deceangli, a tribe whose territory stretched east from the area of the River Conwy towards the present border with England.

Of its type Pen Dinas is quite a small example, though at its peak of occupancy it may have been home to around a couple of hundred people. It is not known if the hilltop was lived on continuously, or whether it was a temporary place of shelter for herdsmen, or for those who lived nearby seeking refuge from attack. It is likely that its use changed over the centuries as circumstances dictated.

Many questions can be raised about the purpose and history of this site. The main reason why there are so few answers is that no excavation of the settlement as a whole, nor the defences – which may produce indications of conflict – have been undertaken. Archaeological examination of two of the sixty-five roundhouses within the settlement revealed evidence of butchered cattle, sheep and pigs and the harvesting of the shoreline, with limpet, mussel and oyster shells. The artefacts discovered included a piece of Roman pottery, which suggests that the site was occupied in the Roman period, though it was, perhaps, lived upon only occasionally and with a reduced population as need arose.

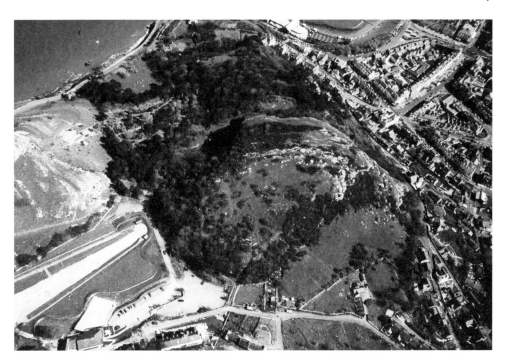

An aerial photograph showing the spur on which Pen Dinas was established. To the east (the top right, above the town) a cliff formed a formidable obstacle for any attackers. Three or four embankments of stone and earth lay approximately across the centre of the site, parallel with the cliffs. The settlement lay between these defences. (Courtesy of Gwynedd Archaeological Trust)

The Iron Age hill fort of Caer Seion, across the estuary on Conwy Mountain, is in direct line of sight from Pen Dinas. If both sites were occupied at the same time, were they friendly neighbours or raiding foes?

8

The Romans

Britain was invaded in AD 43 by the Roman forces of Claudius (AD 41–54), an emperor anxious to acquire military prestige. The low-lying south and east of Britain was subdued relatively quickly, firstly under governor Aulus Plautius, then by his successor, Ostorius Scapula. Ostorius then set about campaigning against troublesome Welsh tribes. The Deceangli, who were likely to have had in their ranks warriors from the Creuddyn, yielded to the Roman forces. The subjugation of the more warlike Ordovices, whose territory covered the rest of north Wales, was completed by Julius Agricola in 77/8. During this later period the Roman fort of Canovium (Caerhun) was established, some 7 miles or so south of Llandudno, strategically placed on the crossing point of the River Conwy on the road from the major fort at Deva Victrix (Chester) and on to Segontium (Caernarvon).

No published material records major settlements or Roman roads in the Creuddyn, though scattered evidence such as fragments of Roman pottery are known. This is not to suggest that its residents remained aloof from Roman affairs, nor that intriguing finds have not been discovered. It has been suggested that the copper mines on the Great Orme were reopened by the Romans. One piece of evidence used in this claim is that hoards of bronze Roman coins found in the area were destined to become pay for the copper miners. However, at a level above the parochial similar hoards of comparable age have been unearthed across the north Wales coastal region and on Anglesey. These hoards have also been implicated in attesting to troubled times. A person's life savings may be concealed underground when a threat of invasion or from raiding parties emerges, though these are not the sole reason for this activity. With the absence of banks or other safe places to deposit treasure, it would be hidden from view of anyone, perhaps especially our neighbours, and reclaimed when it was necessary to do so, such as when the time arrived to pay taxes. Hoards still in the ground centuries later clearly were not reclaimed by their owners. They may remain unrecovered if the burier had been killed during conflict; it may also be the case that they had died of natural causes or been relocated elsewhere. Though local hoards may indicate troubled times, other interpretations for their burial and lack of reclamation have to be borne in mind.

Major Roman hoards unearthed hereabouts fall into three groups: the first includes three hoards (one from the Great Orme, two from the Little Orme) deposited c. 293; the second includes one dating to c. 315 (Bryn Euryn) and another to c. 320 (Little Orme); and the third group comprises a single hoard dating to c. 388 (Great Orme) – this is discussed in the next section.

In 260 Postumus, the governor of Upper and Lower Germany, was declared emperor by his troops. He soon added Gaul, Britain and Spain to his domain, which under him and subsequent emperors became the breakaway Gallic Empire. It remained independent of central Roman authority until 274. Britain was again subject to regal ambition in 286 when Carausius, who had been given the task of

clearing the channel between Britain and Gaul of pirates, turned native, becoming a pirate himself. To avoid retribution from Rome he escaped to Britain, where he styled himself emperor. He was murdered by his chief minister Allectus in 293, who wore the imperial purple until 296, the year Constantius Chlorus invaded and defeated him in battle, thus restoring Britain to the empire.

The coins in the first group of hoards include a few from the Gallic Empire. Rarer still are official Roman issues, with the overwhelming bulk (approximately 626 out of 752) being issues of Carausius – and it may be noted that no coins of Allectus are recorded. Troubled times and coin hoarding seems to suggest conflict in the locality in AD 293, but as the focus of the troubles lay in the south and east, conflict with whom, outsiders (such as raiders from Ireland), factions within the Roman army, or local bandits taking advantage of any prevailing confusion? Their continued concealment may indicate that their owners were killed or taken captive. Nevertheless, there is an additional possibility: new regimes often demonetarised the coins of their predecessors and they became worthless. Away from the conflict hypothesis we might imagine a long-suffering resident of the Creuddyn sighing as his (or her) life savings were made valueless overnight and not worth the bother of digging up.

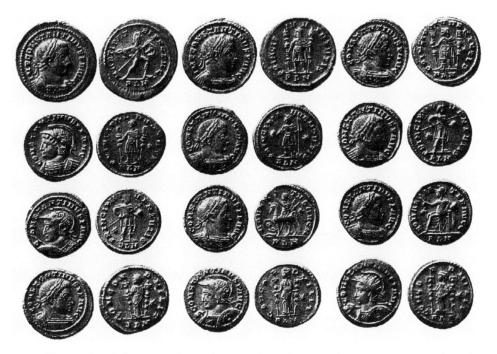

A small sample of the coins from the 1873 hoard, minted in Britain or Gaul, with a terminal date sometime after *c.* 320. These examples show 'PLN' at the bottom of the reverse, which signifies that the coins were produced in London – '*Pecunia Londinium*', 'Money of London'. The first (top left) shows Constantine I (307–337) and, on the reverse, Mars, the god of war. The hoard contained over 3,000 coins of Constantine.

During the period the hoards from *c.* 315 (six coins) and *c.* 320 (5,000 plus coins) were being deposited the focus of the Roman Empire was heading east, away from Rome, to Constantinople, as Germanic invaders repeatedly attacked (and infiltrated) the empire's north-eastern flank. Furthermore, from the west the Irish were becoming avid slave raiders and pirates. The coins in the Little Orme hoard are in uncirculated condition, fresh from the mint, so may have been concealed by a Roman official, though the reason why is unknown, and while it is easy to view the coins' burial as a response to the prevailing circumstances, the cause could have been more mundane.

The Irish

The western seaways of Europe had provided significant links for coastal traffic since the Neolithic and contact between Ireland and the British mainland predated the arrival of the Romans. Commerce criss-crossed the Irish Sea, with the inevitable addition of those for whom piracy offered an easier living. Towards the end of the fourth century this ignoble activity intensified, culminating in 367 in the so-called 'conspiracy of the barbarians'. This proposal assumes a widespread seaborne attack on the ailing empire from the Irish to the west and from Germanic tribes to the south and east; in the north, from beyond Hadrian's Wall, the Picts redoubled their assaults southwards, by sea and by land. Added to this in 383 a high-ranking Roman officer, Magnus Maximus (renowned in Wales as Macsen Wledig), was proclaimed emperor by his troops. He immediately took an army to invade Gaul, thus possibly compounding local difficulties. It is against this background that the small hoard concealed on the Great Orme in *c.* 388 (the year Maximus was executed) can be placed. Roman administration irreversibly left these shores soon after 410.

From here on piratical behaviour by Irish seafarers was often rampant along the coasts of Wales (and beyond). North Wales attracted particular attention from the province of Laigin (now Wicklow and Wexford). It also appealed to colonisers from Ireland who settled in small communities around the coast, including, it has been said, the Creuddyn, though whether this was non-violently is uncertain.

Deganwy: The Establishment of Welsh Kings and Encounters with the English

With the departure of Roman authority a power vacuum ensued throughout the land. Petty kingdoms arose, usually headed by a king who may have been a relatively high-ranking local under Roman governance. Some asserted their right to power by claims of descent from illustrious individuals such as Macsen Wledig. It did not take much time before raiding and warfare broke out between neighbouring groups while dynastic rivalry wrought conflict within families. Unfortunately for all this, the written records on which much of this history is based may be, at best, unreliable. Some were composed decades or centuries after

the events they recount and their creation may owe more to endeavouring to support a contemporary faction or belief system than to any accurate chronicling of people and events. Archaeology can also be at odds with them.

That being said, the twin hills of the Vadre, Deganwy, are believed to have been a key site for this period. Finds including bronze coins from the time of Gallienus (260–268) to Valens (364–378), along with scraps of pottery, suggest that it was occupied as a Roman lookout post against Irish raiders.

A tradition that stresses British unity (that is, of Celtic-speaking peoples, descendants of the pre-Roman tribes) was in place by 830. It tells of Cunedda Wledig, who came from the north either during the late Roman period or soon after to expel the Irish from north Wales. He also founded the dynasty of Gwynedd. One of his alleged descendants was Maelgwn (often anglicised to Maelgwyn) Gwynedd (d. *c.* 547) whose court is assumed to have been sited on the Vadre. Excavation has revealed fragments of imported amphorae which once contained wine, indicating that Maelgwn's court had significant links with the wider world. This location probably continued as a royal residence up to 812, the year the *Annales Cambriae* tells us that it was burnt to the ground by a lightning strike. It was presumably rebuilt as in 822 it was again destroyed by fire but this time by the hand of Ceolwulf I (821–823) of Mercia, the English kingdom to the east of the dyke constructed during the reign of the Mercian King Offa (757–796). In earlier times Gwynedd and the Mercians had been allies, but, as is the nature of these things, they became acrimonious foes. The site withdraws from history after these setbacks; it would rise to prominence again two centuries later.

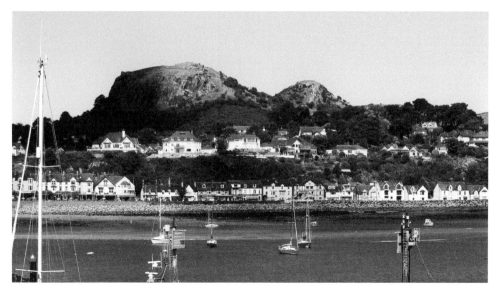

The strategic location of Maelgwn's stronghold on the Vadre, Deganwy, overlooking the River Conwy.

The Vikings

Compounding the troubles emanating from English lands a new menace was emerging from the north and west in the decades following Deganwy's destruction. The Vikings had begun their attacks along the coast of Wales, especially from their base in Dublin after they had defeated the Irish in 841. The Irish Sea became a 'Viking Lake'. A small fleet of their vessels – usually about a dozen strong – must have been a terrifying sight for residents of the Creuddyn. It is thought that Llandudno's twin promontories were named by them, 'Orme' being a derivation from Old Norse for 'sea serpent'. The Great Orme might have appeared as a dragon when first seen from Viking longboats shadowing the coastline eastwards.

By the late tenth century the Vikings were adept at fighting on land, not only on the sea, and the Danish King Cnut (1016–35) came to rule England. Two hoards comprising coins of this reign have been discovered on the Creuddyn, both probably buried in 1024 or soon after. The first, a major collection unearthed on Bryn Maelgwyn (Maelgwyn's Hill), contains 204 specimens, which, with one exception, are pennies of Cnut, mostly in pristine condition. The mint at Chester was responsible for 171 of them. The exception is a penny of the Hiberno-Norse king of Dublin, Sigtryggr Olafsson – also known as Sihtric Silkenbeard (1000–36) – though cut using English dies from Chester. The second hoard, from the vicinity of St Tudno's Church cemetery, comprised four coins (one an imitation) in the name of Cnut.

In the middle distance, swathed in woodland, beyond the southerly reach of Llandudno, lies Bryn Maelgwyn.

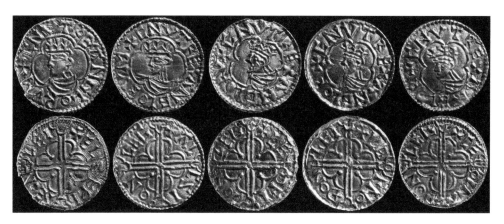

Pennies of Cnut from the Bryn Maelgwyn hoard. The obverse legend reads '+CNUT REX ANGLORUM' (or variations of this): 'Cnut, King of England'. In this period coins were struck by moneyers under licence from the king, such as the first here, '+EL FPI NE O N LEI' – 'Aelfwine on Leigecaester' (Camp of the Legions) – Chester. (© National Museum of Wales)

The main contender for why the coins of the Bryn Maelgwyn hoard came to be on the Creuddyn is that they were Viking booty. The original name of the Great Orme in Welsh is Cyngreawdr Fynydd, 'hill of assembly', and it is tempting to speculate that the second hoard was placed close to St Tudno's Church – assuming an ecclesiastical building was in situ in the early eleventh century – if they were associated with a public gathering. Some suspect that both hoards may have been linked to a royal palace at Deganwy. In 1023 Llewelyn ap Seisyll, King of Gwynedd, died and a period of chaos followed until his son became king in 1039. It is possible that the coins were hidden as a consequence of these unsettled times.

Deganwy: Welsh Kings and English Invaders

When Harold II of England defeated the combined forces of his brother Tostig and Norse King Hardrada at Stamford Bridge (near York) on 25 September 1066 Viking influence in Britain waned. It was to be replaced by an even greater threat when, nineteen days later, he lost the Battle of Hastings. The Normans had arrived on these shores and were soon making their presence felt in Wales.

In Rhuddlan to the east, Robert of Rhuddlan, the deputy of Hugh Lupus, Norman Earl of Chester, raised a motte-and-bailey castle in 1073. At this time, and with much intrigue on all sides, civil war was stirring for the throne of Gwynedd between Gruffudd ap Cynan and Trahaearn ap Caradog. Gruffudd was forced to retire to Ireland, only to return to Wales where he was captured and imprisoned at Chester. After his escape he again fled to Ireland, to the city of his mother, a daughter of the royal house of the Scandinavians of Dublin. All this gave Robert

the chance to extend his domain towards the River Conwy where, in this border zone in *c.* 1080, he built a wooden castle on the now ancient site of Deganwy.

Robert's successful career came to an unexpected end in 1093. The (probably embellished) story is that early one afternoon Robert was in Deganwy Castle when Gruffudd and his raiders (who included Irish and Danish in their ranks) beached their ships under the Great Orme and plundered the land. Robert called for his troops but as the tide was rising fast and the boats would soon refloat he rushed down to attack the marauders, accompanied only by his faithful knight Osbern d'Orgères. Such foolhardiness made him easy prey for the forces on the beach of West Shore. Robert's lands in Gwynedd were taken over by Hugh, but another Welsh revolt – partly in response to Norman brutality on the Creuddyn and elsewhere – led by Gruffudd in 1094, resulted in the loss of most of the territory Robert had gained. Now in Welsh hands, the buildings on the Vardre were to be described as a 'noble structure' by Giraldus Cambrensis in 1191.

With many groups vying for power – invaders and local rivalries – alliances were formed ('the enemy of my enemy is my friend'), though these were often fragile affairs as the Welsh were drawn more closely towards the authority of the English crown. The relationship between Llewelyn ap Iorwerth (1195–1240), King of Gwynedd (and most of north Wales by 1202), and John of England (1199–1216) began quite cordially. By 1205 Llewelyn had married Joan, John's illegitimate daughter, thus cementing the alliance. Things quickly began to fall apart, however, when Llewelyn extended his power into south Wales and four years after the marriage the forces of John were moving towards Gwynedd. The noble structure of Deganwy (and anything else of utility to invaders) was destroyed as part of a 'scorched-earth' policy in 1210; Llewelyn removed his forces and provisions across the River Conwy. Armies from distant places could be trapped on this peninsular and starved into submission or retreat. John occupied the now derelict site in 2011 and realised that they were left with inadequate supplies to continue the campaign. His hungry, vulnerable and dejected forces eventually abandoned the venture and withdrew to England. A castle of wood was subsequently erected on the site by the Earl of Chester, which was captured by Llewelyn in 1213, who quickly set about rebuilding it. The excavations of 1961–66 found some traces of Llewelyn's castle, including a stone bust that is thought to represent the king.

On Llewelyn's death in 1240 Henry III (1216–72) obstructed the accession of his successor, Henry's policy to subdue the Welsh being one of 'divide and conquer'. Inevitably this provoked conflict and in 1244 English forces again marched across north Wales. Dafydd, Llewelyn's legitimate heir, did as his father had and destroyed the castle before fleeing across the river. For a second time English forces huddled in tents, scavenging for food in the surrounding area while the Welsh employed hit-and-run tactics. Much bloodshed was endured by both sides. The English began to rebuild the castle in readiness for Henry's visit in 1245.

By 1254 a substantial medieval fortification loomed above Deganwy. The notable remnants of masonry on the site date from this period.

Henry issued a royal charter in 1252 that created a borough adjacent to the castle, but continuing raids by the Welsh culminated in the castle being besieged by Llywelyn ap Gruffudd (grandson of Llewelyn ap Iorwerth) in 1257. The English-held castle fell and was destroyed by 1263. Henry recognised Llewelyn as overlord of Wales in the Treaty of Montgomery (1267).

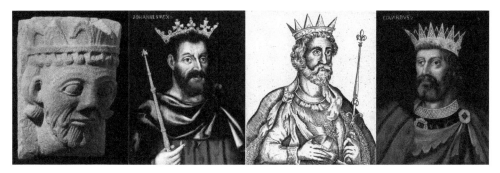

Four kings associated with Deganwy: Llywelyn ap Iorwerth, John, Henry III and Edward I (1272–1307). The portraits of the English kings were produced in the early seventeenth century, derived from effigies on their tombs. (Llewelyn © National Museum of Wales; English kings © National Portrait Gallery)

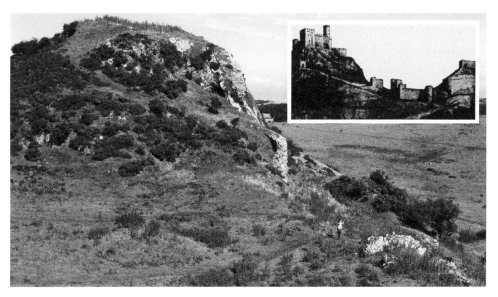

The figure towards the lower right stands at the gateway in the curtain wall, masonry from which can be seen to her right and on her left, snaking up the slope towards the site of Mansell's Tower. *Inset*: Produced *c.* 1910, an artist's impression of Henry III's castle, donjon on the left, Mansell's Tower on the right, curtain wall and gate between.

This was not to be the end of it. A battle-hardened general ascended the English throne in 1272: Edward I. He arrived in Deganwy in 1283 – and became another English king to camp on the Vadre – but seeing how easily the castle had fallen and recognising the strategic value of a riverside site where reinforcements and supplies could be delivered by sea, he founded his castle and town across the river at Conwy. Deganwy was abandoned. Welsh independence perished with the deaths of Llewelyn in 1282 and his brother Dafydd in 1283.

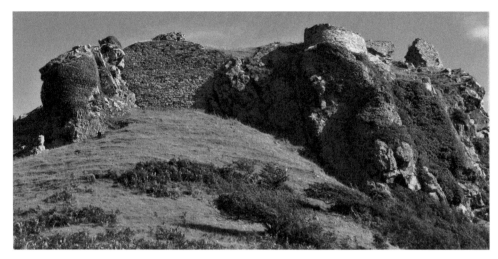

The retaining wall on the left may date from Llewelyn's rebuilding of 1213. The round tower on the right is from the time of Henry III.

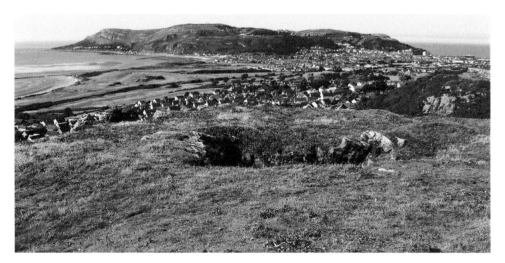

The panorama from the donjon, towards West Shore, Llandudno, and the Great Orme. The quarry from which stone used in the castle's construction was taken lies in the foreground.

A landscape enriched with history: the viewpoint from Pen Dinas, with the Vadre and, across the river, Conwy Castle.

Gogarth Grange

Edward maintained personal control of the Creuddyn (hence this bit was in Caernarvonshire) to act as a safeguard to the mouth of the River Conwy. With little contemporary evidence for the story it has been proposed that Anian, the Bishop of Bangor, sided with Edward in 1277 and christened Edward's son in 1284 as the 'Prince of Wales'. Be that as it may, he continued as Bishop of Bangor until his death in 1307. The story continues that for his service to Edward he was granted licence to build a residence on the Great Orme. A building often (and erroneously) referred to as Gogarth Abbey (also known as the Bishop's Palace) was in place around 1300. It was built in the style of a medieval longhouse, with one main room and smaller rooms towards the estuary and to the north; given this, it might be better described as a grange.

Around 1400 it was burnt to the ground by forces of Owain Glyndwr during the final attempt to place a Welsh king on the throne of Wales. Glyndwr's rebellion was unsuccessful, Anian's grange fell into ruin, and the Creuddyn faded from history.

Gogarth Grange, precariously perched above an eroding section of coastline.

A large scar in the landscape of the Great Orme, across from the Summit Complex, is known as 'Bishop's Quarry', believed to be the source of building material for Gogarth Grange.

Recusants, Civil War and Shipwrecks

Whereas Edward's Statute of Wales (1284) annexed Wales to the English crown, Henry VIII's government enacted measures from 1536 declaring the king's wish to incorporate Wales within the realm, expressing that the law of England was to be the only law of Wales. Henry also initiated the Reformation, with the protestant Church of England established in 1559 – which a number of Roman Catholics refused to attend. By 1581 saying or hearing mass was punishable by fine and imprisonment; being a priest was punishable by death after 1585. Notwithstanding these penalties Catholicism continued clandestinely, and those following this course of action became known as recusants.

In the Creuddyn the Pugh family of Penrhyn Old Hall were prominent recusants who practised their religion in a small chapel in the grounds. The hall itself is replete with a 'priest hole' and a stone dated 1590 above the fireplace commemorating the Pugh's domestic chaplain, William Davis. In 1641, the year before Civil War broke out, it was rumoured 'that the recusants of Creuddyn are preparing their arms and mean ill towards the town of Conway'. A search was made by 'those nominated by Parliament to disarm recusants', though 'no danger appeared' and nothing came of it.

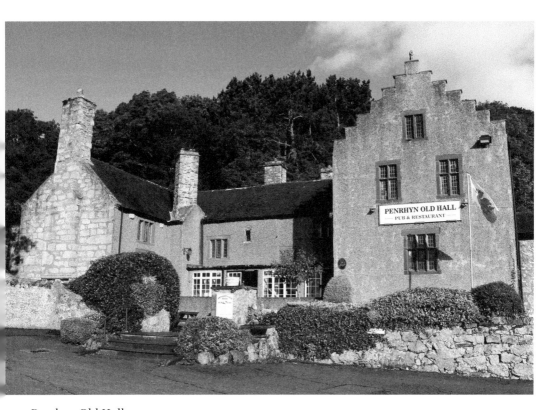

Penrhyn Old Hall.

Penrhyn Chapel with the Little Orme beyond. The structure may date from the early sixteenth century.

Up until the last century those lower on the social scale that comprised the bulk of the army and navy were invisible to history. We simply do not know if any of Charles I's contingent of 5,000 Welshmen at the Battle of Edgehill (1642) were from the Creuddyn, nor in any of the other conflicts of this war. We can only suspect their presence: squires such as Hugh Wynne of Bodysgallen Hall to the south of Llandudno raised regiments on the king's behalf and in 1646 Captain Robert Pugh of Penrhyn Old Hall commanded the seventy troopers defending Conwy Castle.

Over the centuries the sea has been a major agency of communication, sustaining commerce and social contact. It could also be a dangerous ally, especially around the precipitous cliffs and stormy raging breakers of the Great Orme. The first reportedly recognised shipwreck was the *Phoenix* in January 1642, although why she was in the vicinity of the Great Orme is unknown. In the October of 1641 rebellion had erupted in Ireland. The *Phoenix* was hired at Dublin sometime in the autumn of that year to assist Charles I's newly built HMS *Swan* in quelling the Catholic uprising. That an Irish privateer should be employed for this purpose is also somewhat baffling.

A *c.* 1900 artist's impression of a sailing ship in difficulty off the Great Orme.

Copper Mines

Economic conditions were felt to be favourable for reopening the copper mines in the late seventeenth century, though they operated only sporadically until the nineteenth century. The boom years for the three mines operating on the Great Orme were from the 1830s to the 1850s. One of the uses for this copper was to provide sheathing to protect the hulls of wooden vessels and for bolts to hold the ships together. This was of particular importance for the expanding British navy operating in tropical and equatorial waters. Unfortunately for this industry protective import tariffs were lifted in 1848, this around the same time as cheaper ores became available from overseas. A further influence on the fall of the price of copper was the evolution of ironclad ships. The mines became uneconomical, with the last closing in 1881. By then the nature of war was changing: the design and construction of ships were undergoing radical transformations, and firepower, both small arms and artillery, were advancing rapidly into weapons of greater destruction. The scene was being set for wars that came later in the century, and those of far greater devastation of the twentieth. A further profound change was to emerge: the 'rank and file' – combatants and fallen heroes – and, later, civilians caught up in conflict began to be documented and remembered as named individuals, especially within local communities.

Llandudno's First War Memorial

In September 1903, during an unseasonal hailstorm, Llandudno's first war memorial was unveiled at St Tudno's churchyard on the Great Orme. This granite sentinel, paid for by public subscription, commemorates the four local men who

died during the Boer War: Sergeant Charles Jones, Lance Corporal Owen Roberts, Trooper George Goodwin and Private Harry Deverell.

At the outbreak of the second South African War in October 1899, commanders confidently predicted a swift and decisive victory. Instead, the British suffered a series of humiliating defeats and significant losses. These setbacks at the outset of the war prompted the government to modernise and re-equip the army, and it called for volunteers to augment the ranks. Forty eager young Llandudno men willingly enlisted and sailed for South Africa – the highest percentage from any town in Britain, the local newspaper proudly boasted.

Days after the volunteer soldiers left Llandudno, the 'Transvaal War Relief Fund' was established to help their dependents. The great and the good contributed, led by Lady Augusta Mostyn, who generously donated £50, equivalent to six months wages of a skilled tradesman. Her son, Lord Mostyn, was not so charitable, giving £10 to the cause. Over £500 was donated by an enthusiastic and patriotic public including 6s from Mr Hutton of Linden Cottage, who sold a puppy (a fox terrier-Dalmatian cross) for the fund.

After reinforcements arrived in South Africa, the tide of the war changed rapidly. With superior equipment and number of combatants, the British army quashed the uprising. The volunteers were welcomed back to Llandudno as heroes, with a civic reception at the Town Hall and a banquet at the Cambridge Restaurant on Mostyn Street.

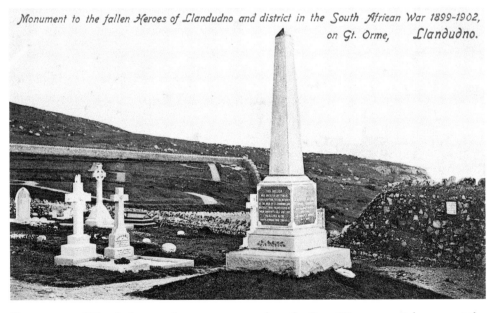

Monument to the fallen Heroes of Llandudno and district in the South African War 1899-1902, on Gt. Orme, Llandudno.

The quartet of Llandudno youth commemorated on the Boer War memorial were not the last to fall serving their country in the twentieth century, a hundred turbulent years that saw humanity develop ever-increasingly violent and industrial ways to slaughter each other.

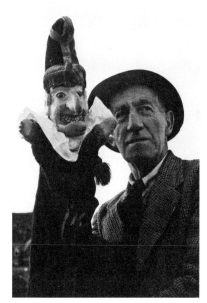

Herbert Codman was among the Llandudno volunteers who fought in the Boer War. Son of Punch and Judy 'Professor' Richard Codman, he served with the Royal Welsh Fusiliers. After his father's death Herbert took over the running of this popular Llandudno institution. At the outbreak of the First World War Herbert was recalled but was injured and invalided out of the army. During the Second World War Herbert once again volunteered for military service and joined the local battalion of the Home Guard. (Courtesy of Jacqueline and Jason Codman-Millband)

Fit Enough to Fight

Eleven short years after the unveiling of the Boer War monument on Llandudno's mountain, Europe was plunged into chaos. On the evening of 28 June 1914, a minute before 8 p.m., the orchestra struck up at the Pier Pavilion and played Chopin's funeral march. There was no notification on the concert programme notes but the thoughts of the audience turned at once to the Austrian people deeply mourning the assassination that day of the heir to the throne of the Austro-Hungarian Empire by a Serbian nationalist. Archduke Ferdinand's death triggered a four-week diplomatic crisis in which a complex network of political alliances drew Russia and Germany to the brink of war. When Germany invaded neutral Belgium on 4 August, the British Empire came to Belgium's aid, as it was obligated to do so by a treaty signed in 1839, and declared war on Germany.

In Llandudno reservists and territorials were called up and departed for their barracks; the following day senior army officers visited the town and the call-ups were not people, but animals. From the donkeys on the beach to ponies that hauled delivery carts, a town that relied on horsepower lost sixty of its work steeds to the frontline. Pleasure boats that plied their trade along the coast were commandeered by the Admiralty including the *La Marguerite*. which was converted into a troopship, and over four years conveyed over 360,000 troops to and from France. Huge pressure was exerted on men to volunteer. The Urban District Council urged Llandudno Football Club to cancel all its matches, telling them that 'if they were fit enough to play football then they were fit enough to go and fight'. The club refused and instead invited a delegation of councillors to the next game. Taking to the pitch the councillors exhorted the players to volunteer. Many did.

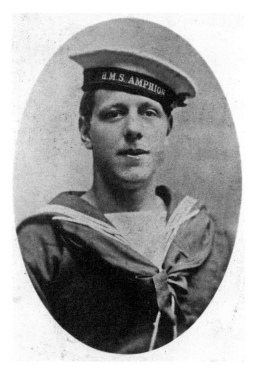

Left: Daniel Evans was the first local casualty of the First World War when HMS *Amphion* was mined in the North Sea, two days after the outbreak of hostilities. Invalided out of the Royal Navy, he later enlisted into the Royal Garrison Artillery, was gassed on the Western Front and returned to Llandudno to convalesce, but died in October 1919.

Below: Five weeks after the first local soldiers left, a telegram was delivered to the landlord of The Albert Hotel on Madoc Street notifying him of the death of his son, Llewelyn Roberts. The thirty-three-year-old postman was the first of more than 200 Llandudno men killed during the First World War.

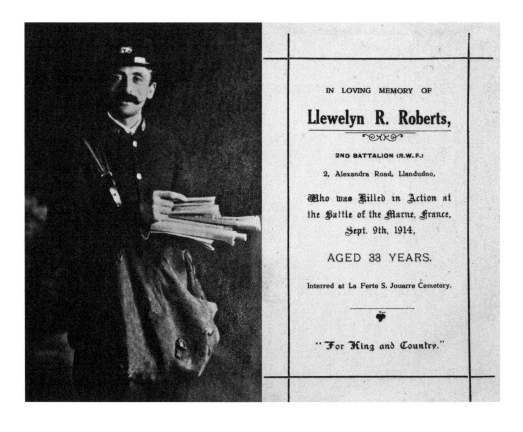

IN LOVING MEMORY OF

Llewelyn R. Roberts,

2ND BATTALION (R.W.F.)

2, Alexandra Road, Llandudno,

Who was Killed in Action at the Battle of the Marne, France, Sept. 9th, 1914,

AGED 33 YEARS.

Interred at La Ferte S. Jouarre Cemetery.

" For King and Country."

Where Have the Holidaymakers Gone?

When Herbert Asquith declared war, it was peak holiday season in Llandudno with its well-heeled visitors enjoying the town's attractions. Following the announcement, holidaymakers packed up their valises and went home, nervous about what the immediate future held. This proved to be an economic disaster and the council was under immense pressure to respond. It came as a great relief to local businesses when it was announced that five battalions of the newly formed Welsh Army Corps, an all Welsh division championed by David Lloyd George, would be accommodated in the seaside resort.

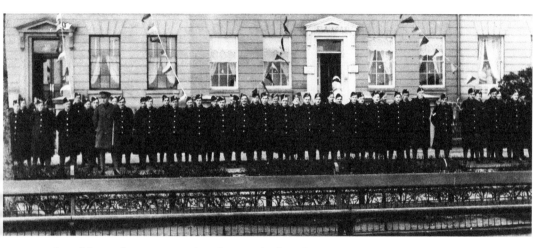

Royal Welsh Fusiliers wearing 'Kitchener Blue' uniforms outside the Elsinore Hotel. This livery was issued to new recruits as there was a shortage of khaki. Soldiers wearing it were often derided for looking like postmen, since it came from surplus post office stocks.

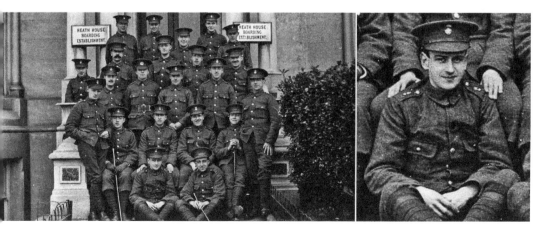

Soldiers outside Heath House Boarding Establishment on Llandudno promenade. The fusilier on the front row is wearing a black 'mourning' button indicating the loss of a loved one in the war.

Some 6,000 men of the Royal Welsh Fusiliers were billeted in Llandudno between November 1914 and September 1915. If the soldiers were expecting luxury lodgings, they were in for a rude awakening as they had to make do with a mattress on the floor and all other furnishings were removed. If the landladies were expecting a bumper pay day on the back of their military guests, they too were in for an unpleasant discovery as the promised remuneration of 3s 3d per soldier per day was rescinded, and cut by two thirds. The War Office stipulated that each soldier would receive the same food ration: bread, bacon and a pint of tea for breakfast; meat and potatoes washed down with a pint of water for dinner; and bread, cheese and another pint of tea for supper.

The schoolrooms of five town centre churches were used for soldiers' quiet enjoyment and recreation. The lecture room at the library was placed at their disposal as a writing room while the public bar of the Welcome Hotel, Vaughan Street, was opened for soldiers to play draughts or chess. Llandudno's public houses did a roaring trade but following a series of fights the council ordered licensed premises to close at 9 p.m. – this was not popular with the locals.

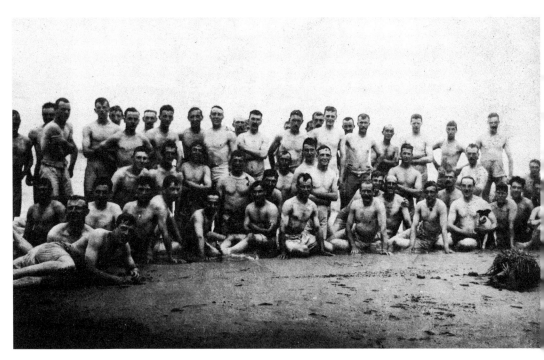

The soldiers trained on the Great Orme, where practice trenches were dug. They were drilled on the promenade, did physical exercises on the beach and swam lengths in the bay. (Courtesy of Elizabeth Turner/Mary Oliver)

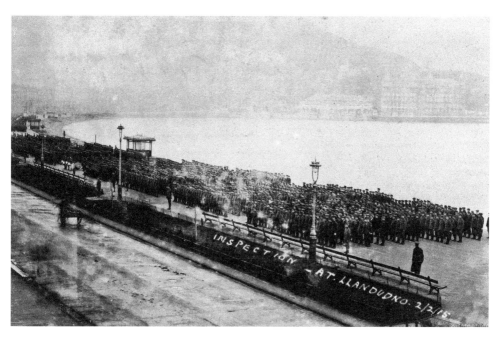

On St David's Day 1915 an *eisteddfod* and concert were organised to coincide with the visit of the Chancellor of the Exchequer and Caernarvon Boroughs MP, David Lloyd George, who inspected the troops on the promenade.

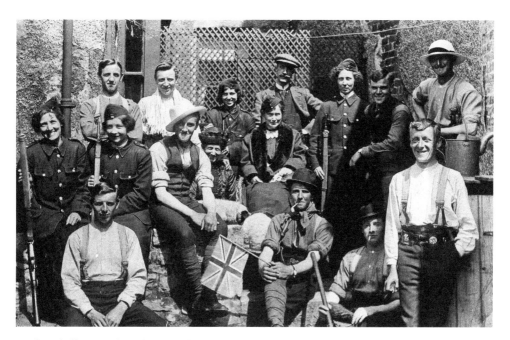

At their billet on Chapel Street these Royal Welsh Fusiliers are relaxing with the ladies of the household – the girls wearing the soldiers' tunics and holding their rifles. (Courtesy of David Kyffin)

The Plucky Belgians

In the days before the outbreak of the war the German government demanded that her armies be allowed free passage through Belgium to reach France. These requests were refused and Belgian neutrality was ignored. The Belgian army put up stubborn resistance and held up the German offensive for nearly a month. This came at a great cost to the Belgian people – thousands of civilians and soldiers were killed or wounded and more than 250,000 non-combatants sought refuge in Britain. In Llandudno Belgian exiles were found quarters at Lansdowne House, One Ash and Corona House.

In October 1914 a train carrying eighty wounded Belgian soldiers steamed into Llandudno railway station, greeted by a crowd of cheering well-wishers. The injured soldiers waved back, their tin helmets held aloft in appreciation as they made their way to the charabancs that conveyed them to Lady Forester's convalescent home on Queen's Road. One Belgian soldier was no more than a child; a couple of months earlier Nestor Swille was a carefree schoolboy in Brussels, but by the time he arrived in Llandudno he was a battle-scarred warrior. The thirteen-year-old ran away from home with the intention of 'doing his bit' for his country and joined his older cousin in the army. He was given a rifle, a bicycle, a helmet and the job of messenger, and through summer 1914 rode his machine without incident. At Haacht, in central Belgium, he was

Lady Forester's Convalescent Home opened in 1902 and at the outset of the First World War was put at the disposal of the military authorities. Today it is the home of military charity Blind Veterans UK.

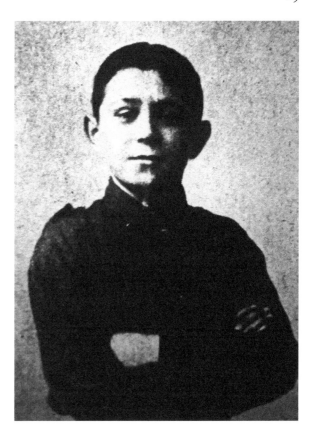

Nestor Swille.

knocked unconscious from the force of an enemy shell and blood-soaked from shrapnel wounds. Badly injured, young Nestor ensured that his message was delivered by another dispatch rider before being taken to hospital in Antwerp and then on to Llandudno.

Military Hospitals

Lady Forester's was one of half a dozen buildings in Llandudno requisitioned by the military or the British Red Cross for use as hospitals.

The Balmoral was officially opened as a hospital by General Donald in December 1915. Even though it had twice the bed space of Red Court, such was the demand from those needing medical attention, that two buildings on Charlton Street were also requisitioned, taking the capacity to 100, and huts were erected in the grounds of Holy Trinity Church to provide an additional score of beds. Over 1,700 injured soldiers were treated at the Balmoral before it closed in May 1919. Six died from their wounds as did nurse Aldwyth Williams from the Conwy Valley who was tasked with looking after them.

Plas Tudno on Church Walks was another Llandudno property commandeered to treat injured British servicemen. In 1915 there was a noisy demonstration here

when it was discovered that one of the porters was German. Wounded troops insisted that Robert Hempel should be dismissed immediately, and he was duly arrested and interned at a camp in Flintshire. One soldier recuperating at Plas Tudno was Private William Law. Fêted by the media and lauded by local landowner Lord Mostyn, the young Scotsman happily related his tales of derring-do and was a popular speaker on the local circuit. Audiences were enthralled as he recounted his formative years in Greenock and his medical degree at Glasgow University, his life as a cowboy in Montana before striking it rich as a property tycoon on America's east coast. While holidaying in the UK in September 1914 he volunteered for the British army, turning down a commission. He claimed to be a 'brilliant rifle shot' and felt he could serve the 'old country better' in that capacity. Despite having no previous military experience, he was sent to the front just a month after enlisting, boasting that 'I did not require much training.' The tale of his wartime service was remarkable. Law claimed that his regiment was ordered to advance and boldly took three German trenches, but

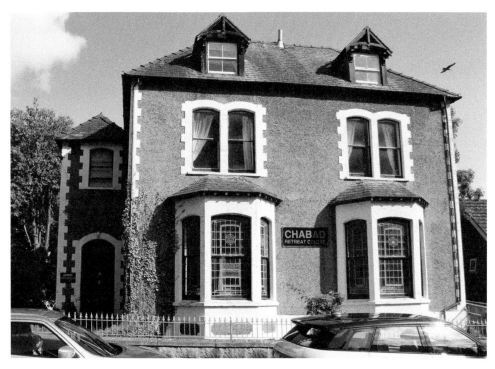

Red Court (now the Chabad Retreat Centre) on Church Walks was put at the disposal of the Red Cross by its owner, Manchester brewer William Lecomber, in 1914. This twenty-five-bed hospital was principally used by locally billeted Royal Welsh Fusiliers before soldiers wounded overseas arrived. In October 1915, with more injured soldiers than available beds, an appeal was made for bigger premises and the YMCA agreed to rent their premises, Balmoral, in Trinity Square to the medical charity.

Above: The Balmoral.

Right: Aldwyth Williams enrolled in the Voluntary Aid Detachment early in the war and died of influenza days before the Armistice in November 1918. On the day of Miss Williams' funeral, the cortege paused outside the Balmoral for the wounded soldiers to pay their respects before continuing to St Tudno's cemetery on the Great Orme. (Courtesy of Jerry Bone)

was forced to withdraw when reinforcements did not arrive. Back in the safety of his dugout, Private Law could hear three badly wounded men crying pitifully as they lay in no-man's land. He dashed to their aid, bringing the trio back and although his clothes were 'riddled with bullets' miraculously he did not lose a drop of blood. For these heroic actions William Law said he was awarded the Distinguished Conduct Medal. Three months later, Law and eleven others were in a trench close to the frontline when it was hit by a shell, killing or wounding all assembled there. Law was badly injured, receiving seventeen shrapnel wounds and was drifting in and out of consciousness. He had the mettle to use his medical training to treat the wounds of the seven surviving soldiers; for saving their lives he was awarded the Victoria Cross. However, there is no evidence that a soldier by the name of William Law and serving with the Gordon Highlanders was awarded either of these honours.

The Great (Orme) Escape!

It was a cold and damp evening when Walter Wood, accountant to Llandudno Urban District Council, left the town's county club. Outside, he was buttoning up his coat against the weather when a soldier approached him, offered him a polite greeting and started walking with him down Lloyd Street. Fearing that he was about to be the victim of a robbery, the accountant turned and ran back to the club in which he had spent the evening. He burst into the lobby followed by half a dozen soldiers excitedly shouting 'We've got him; we've got him.'

For two days hundreds of soldiers had been searching for three German prisoners of war who had escaped from a camp at Dyffryn Aled in Llansannan. The mansion (demolished in 1920) was requisitioned in August 1914 to accommodate captured German officers. Two of the detainees, Lieutenant-Commander Hermann Tholens and Captain Heinrich von Hennig, hatched a cunning plan to escape and rendezvous with a German submarine off the Great Orme. During a prisoner exchange in December 1914 the opportunity arose to get a message to the Commander-in-Chief of the German submarine fleet with their request. Agreement to their proposal was sent to the pair at Dyffryn Aled in a series of coded letters and the date was set.

On the evening of 13 August 1915, Tholens and von Hennig, along with fellow captive Captain Wolff-Dietrich Baron von Helldorf, forced their way through the barred windows of the eighteenth-century house. Although security had been stepped up in the wake of a previous escape attempt, the three Germans evaded the sentries and passed through the front gate. Dressed in civilian clothes, they walked the 20 miles to Llandudno, arriving shortly after dawn. Tholens later recounted how they 'crossed a large training field in the middle of the town and admired, at our leisure, the exercises and drilling of a whole army of soldiers'. Confident that they would not be missed until the camp's morning roll call, the

Dyffryn Aled was described by one Canadian newspaper as 'A happy home for Huns'.
Inset: Lieutenant-Commander Hermann Tholens.

trio enjoyed a meal in a café before hiding for the day. Meanwhile, out at sea, submarine U-38, captained by Max Valentiner, idled in Llandudno Bay.

At dusk, the three Germans left their hideout and attempted to scramble down the precipice below the Great Orme's lighthouse. In the dark waters below U-38 moved towards them, awaiting a signal that never came, as the officers failed to find their way to the foot of the cliff. All was not lost, as the plan was for the U-boat to rendezvous at the same position for three consecutive nights. The escapees returned to their hideout and rested for the day, successfully descending the Great Orme on the second evening. It was a moonless night and despite repeatedly signalling to their naval comrades by waving a torch in a circular motion, they got no reply. In desperation they built a fire of driftwood, scavenged from the rocky foreshore, and waved a large log of flaming wood into the dark. By now Tholens and his fellow escapees assumed that the submarine was not coming. Only years later did they discover that it had been just a few hundred yards away, but so close inshore that their view of each other was blocked by a limestone buttress.

Dejected, cold and hungry the Germans walked into Llandudno, split up, and planned to get a train to London. After buying cigarettes, Tholens went into a café in Mostyn Street where waitress Nellie Hughes served him a cup of coffee and piece of cake. He left the coffee bar and outside the Tudno Hotel was approached by Police Constable Morris Williams, who asked his identity. Williams escorted

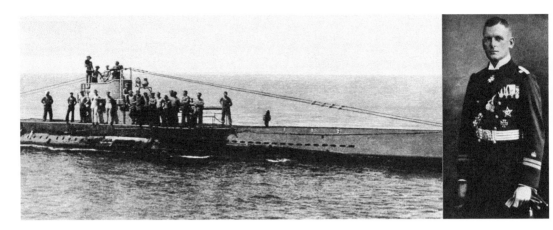

U-38 and its commanding officer, Kapitänleutnant Max Valentiner.

The three escapees on the shore of the Great Orme.

him to the police station. Unable to locate the other two fugitives, the authorities staked out the railway station but no men matching the descriptions entered the concourse. To be certain, the London-bound train was stopped at Colwyn Bay and every compartment searched but to no avail. That evening, around the same time the innocent council accountant sought sanctuary at his club, cab driver Alfred Davies was on his way to pick up a fare from the Pier Pavilion. He noticed two men standing under a lamp in North Parade and asked if they needed a cab. In broken English they asked to be taken 'to the Colonel' so Davies took them to the headquarters of the London Welsh Battalion that was billeted in Gloddaeth Street. The three were tried before a military court at Chester Castle and sentenced to eighty-four days imprisonment in Chelmsford Gaol, without hard labour.

Airship Stopped Play!

In Llandudno Cricket Club's long history there can never have been an incident as strange as the day an airship interrupted play. Since autumn 1915 a Royal Navy airship station at Llangefni, Anglesey, had been responsible for escorting and protecting the merchant ships of the Atlantic convoys from the menace of German submarines in the Irish Sea. Unlike fixed wing aircraft, airships could fly at the same speed as the flotilla and stay airborne for up to ten hours a day. On a sunny afternoon on the last Saturday of June 1918, during a match at the Gloddaeth Avenue recreation ground, an airship was experiencing engine trouble overhead. The pilot scribbled a note and dropped it onto the wicket below. While he circled, the players studied the piece of paper and then using their bodies formed an arrow pointing into the wind. As the airship descended, the crew threw out the trail rope and, like a trained landing party, cricketers and spectators rushed forward and hauled down the balloon. The engineer quickly diagnosed the problem, restarted the engine and, to great cheers, the airship took to the air and the match resumed.

 This was not the first time that mechanical trouble had forced an airship to land at Llandudno. On the afternoon of 26 April 1918 promenaders would have seen the curious sight of a trawler towing a semi-inflated 'blimp' out in the bay. That morning, a Sea Scout airship – with a crew of three – took off from Llangefni to search for a German submarine seen near Formby Lightship. After several hours in the air, the engine seized, and the on-board engineer was unable to restart it. As the craft drifted towards the north Wales coast, its distress signal was picked up by an Aberdeenshire registered armed trawler that came to its aid. The initial plan was to tow the craft to Red Wharf Bay but with the wind strengthening, a heavy swell and patchy fog it headed for Llandudno as the Great Orme was visible through the gloom. From their training camp at Deganwy, a section of Royal Engineers was summoned to the end of Wales' longest pier and took the tow rope from the trawler, walking the stricken airship, high in the air, to the promenade and tethering it by the Hydro Hotel.

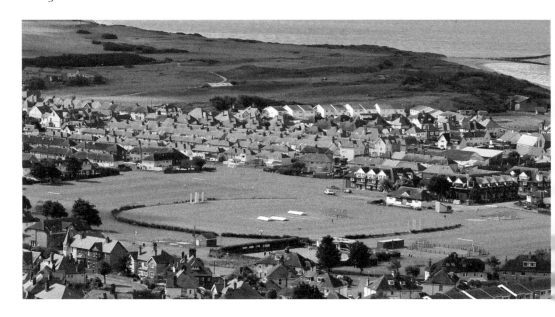

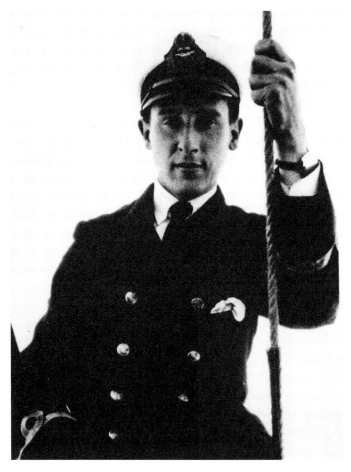

Above: The Oval.

Left: Captain T. B. Williams.

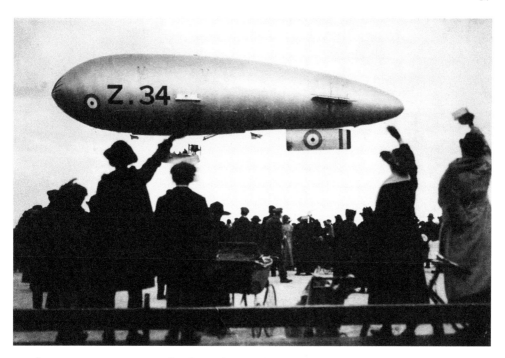

Airships were a common sight along the north Wales coast during the First World War including on Armistice Day when Sea Scout Zero 34 passed over Llandudno promenade firing its Lewis gun. (Courtesy of Robert Barnsdale)

A large crowd gathered, excited at seeing the huge silver balloon moored at such close quarters. The police roped off the area and people were warned about the dangers of smoking in the vicinity of the hydrogen filled airship! The pilot, Lieutenant Williams, was invited to take a bath and meal at the Hydro Hotel but when dressing found that he had no tie to wear for dinner. He was lent one by the hotel manager but later recalled that it 'was very gaudy for a Naval Officer and caused considerable amusement'. While the airship captain dined, mechanics from Anglesey repaired the engine and inflated the balloon's envelope. Problems arose when they attempted to fill the fuel tanks high on the flanks of the airship, but assistance arrived in the form of Llandudno fire brigade with their turntable ladder. By eight that evening, the faulty water pump had been fixed and the craft took off from the beach for the flight back to RNAS Llangefni, known today as RAF Mona.

Mametz

For most of the 6,000 Royal Welsh Fusiliers who trained and were billeted in Llandudno in late 1914 and much of 1915, their first major action was on the Western Front in July 1916. Days after the first troops went 'over the top' on the first day of the Battle of the Somme, the Welshmen were tasked with capturing

the overgrown woodland at Mametz. The first attack ended in failure and three days later another assault was planned. This time the attack was launched at dawn and preceded by a heavy artillery barrage against German positions. Still, many were cut down by enemy machine gun and rifle fire as they crossed the open fields. After fierce fighting, the Welsh troops took the wood by dawn on 12 July and the 38th (Welsh) Division, the new name of the Welsh Army Corps, was taken out of the front line. The division suffered severe casualties with 565 men killed in less than a week including Llandudno lads Wilfred Brown, Alun Davies, Arthur Evans and Ivor Jones.

The village of Mametz, including many of its dwellings and much of its infrastructure, was destroyed in the fighting. At the end of the war, Llandudno adopted the village and through a series of fundraising events amassed over 9,000 francs to restore the water supply. So grateful were the French villagers that the mayor, Monsieur Baudet, came to Wales to thank the residents personally for their generosity. At a civic reception, he told the audience about the destruction of his home village, of the starving community and of farmers struggling to cultivate the land around the deep shell craters in the pockmarked countryside. He also spoke of the perils of ploughing up live ordnance and, worse, the bodies of the fallen.

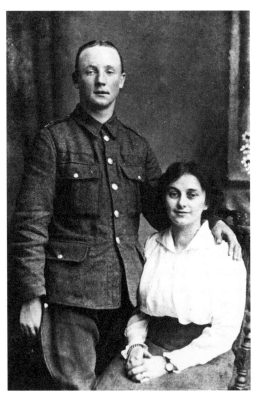

Private Ivor Jones was from Pontllanfraith, Monmouthshire, and at the outbreak of the First World War enlisted in the Royal Welsh Fusiliers and was sent to Llandudno. He met local girl Ann Harrison and they married before Ivor left for France in December 1915. Their daughter, Elizabeth, was born in May 1916 and tragically Ivor died before meeting her.

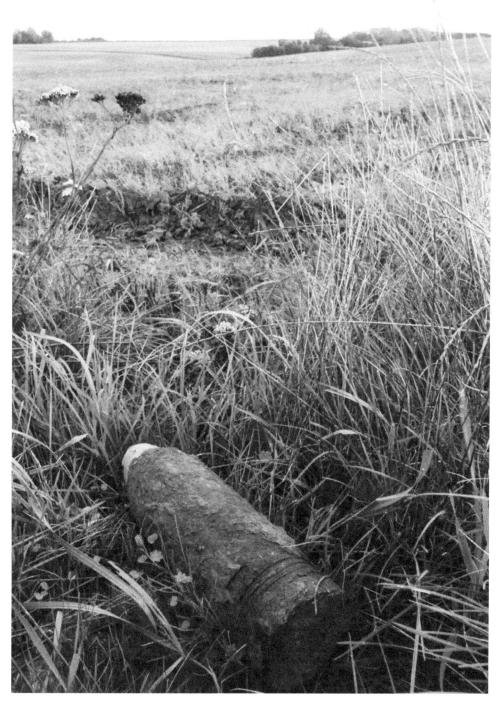

One hundred years after the Armistice today's cultivators still dig up the 'iron harvest', leaving it in the field margins for the authorities to collect.

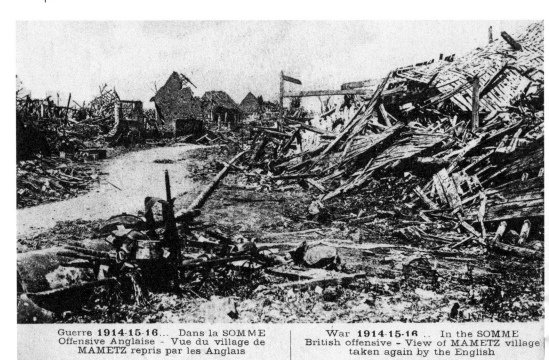

Guerre **1914-15-16**... Dans la SOMME Offensive Anglaise - Vue du village de MAMETZ repris par les Anglais

War **1914-15-16** .. In the SOMME British offensive - View of MAMETZ village taken again by the English

The aftermath of the fighting at Mametz. Intriguingly this photograph was produced as a postcard.

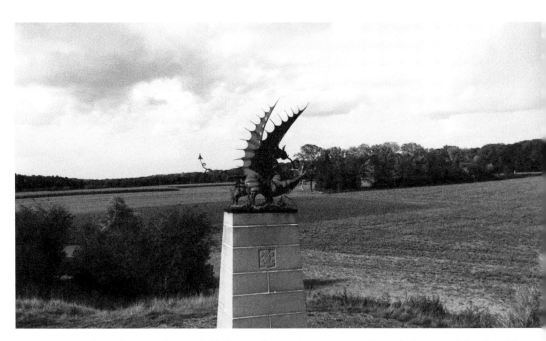

Memorial to the Welshmen killed in July 1916 at Mametz Wood. Designed by David Peterson, it was unveiled in 1987.

Armistice – The War is Over

The First World War ended in the second week of November 1918, just as Llandudno was preparing to host its 'War Savings Week'. It was hoped that £100,000 – approximately £4.3 million today – could be raised in National Savings to help pay for the war. On the 11th, at noon, newspaper sellers on Mostyn Street confirmed rumours that had been circulating all morning that the war was over; simultaneously, a confirmation notice was posted outside the post office on Vaughan Street. Residents of Llandudno reacted with predictable joy and set to work decorating the town with bunting, flags and ribbons. Shortly after 3 p.m. an impromptu parade formed at the railway station, led by local sailor George Edwards carrying a Union flag. As the parade made its way along the promenade the thousands of high-spirited revellers witnessed a British warship sailing into the bay, firing several shots in the air as it did so. That evening while a military band played, beacons were lit on the Great and Little Ormes. The joy at the armistice was tinged with great sadness. For every 100 Llandudno men who had enlisted in the military, fifteen had not returned. One soldier was killed on the last day of the war: Jean Bonnet of Lloyd Street, who died when he fell from a lorry in Italy. The youngest of Llandudno's victims was seventeen-year-old Robert Eccles – son of the lighthouse keeper – who was killed when HMS *Defence* was sunk in the Battle of Jutland. The oldest was grandfather John Jones – an army driver – who died aged sixty.

Peace Day

On 28 June 1919, five years to the day after the assassination of Archduke Franz Ferdinand, the Treaty of Versailles was signed, a peace agreement between the Allies and Germany that brought a diplomatic conclusion to the 'War to end all Wars'. That day, King George V proclaimed 19 July 1919 would be 'Peace Day' and a public holiday across Britain. In Llandudno a subcommittee of the council came up with suitable plans to mark the occasion. Paid for by public subscription, celebrated jeweller Morris Wartski was the most generous benefactor, donating £5 5s to the cause. For the town's 2,500 children, the highlight was taking part in the grand parade that wound along the streets of Llandudno to Happy Valley. As this was followed by representatives of the Women's Land Army, Voluntary Aid Detachment, fire brigade, town band and morris dancers, it stretched over a mile long. The spectacle concluded with twelve lorries, supplied by London & North Western Railways, on which local businesses had assembled patriotic tableaux including 'Victory' by Williams the grocer and 'Angels of Mons' by Baxter, the Mostyn Street drapers.

That evening, crowds thronged onto the seafront for an al fresco gathering that started with a confetti party, where residents and holidaymakers showered each other with petals and coloured paper discs. Jazz bands played while friends

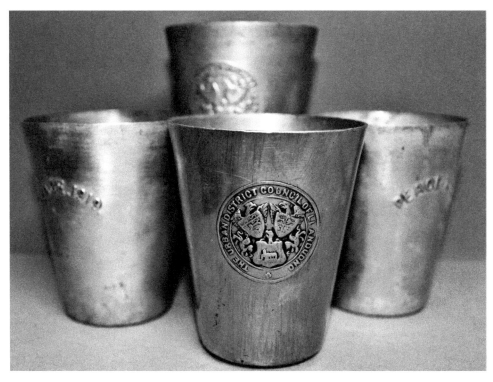

Every schoolchild in Llandudno received an aluminium beaker to commemorate Peace Day.

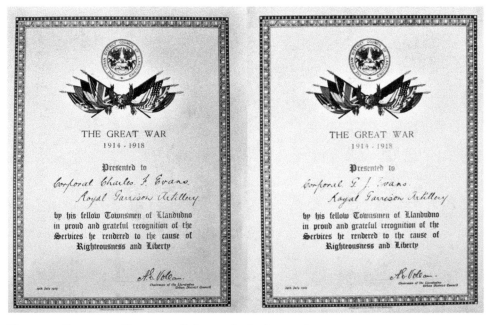

The council gave certificates to all those who had served.

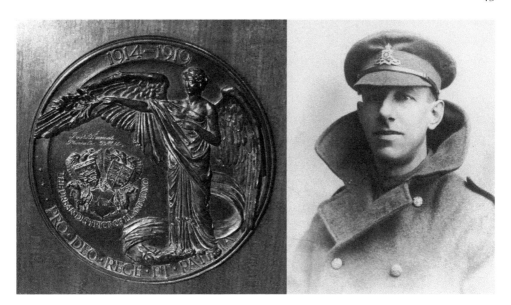

A specially commissioned plaque was presented to the families of the fallen. Ivor Davies died at a German prisoner-of-war camp in July 1918.

and strangers linked arms, gathering more people along the way. The climax to the revelry came when coloured rockets were fired into the night sky from the tower of the St George's Hotel – the council's pyrotechnics having failed to arrive in time – and the lighting of bonfires along the beach and on the lower slopes of the Great Orme. These had been built in the preceding days by eager schoolboys keen to make theirs the biggest and best. Atop one conflagration, a caged effigy of the Kaiser burned wildly to the enthusiastic cheers from the assembled masses.

Llandudno's Second War Memorial
Despite the success of the 1919 peace celebrations, anger festered among the town's discharged sailors, soldiers and airmen. Llandudno Urban District Council cancelled plans to distribute certificates to servicemen at a ceremony on Peace Day, and it was slow to organise a permanent memorial to the war dead, prompting the war heroes to start raising funds independently. Embarrassed by this slight, the council took the opinion that they were the 'proper representative body to deal with the question of the erection of a permanent War Memorial to Llandudno's Fallen Heroes'. A meeting was hastily convened, a subcommittee established and an open competition was organised to architects across the country to design a fitting tribute. The council tried to secure the gardens of the North Western Hotel on lower Mostyn Street to build the new structure and, though the owners were willing to relinquish their lease for the memorial, repeated delays led the council to seek an alternative location. Their second choice was on the promenade at

Prince Edward Square where today local people still make a pilgrimage and pay their respects to the fallen.

In November 1921, John Hobson of Ivy Mount on the Great Orme was invited to cut the turf, the start of work to erect the memorial. He had lost three sons, two sons-in-law and a nephew during the war. Even then, on the third anniversary of the Armistice, emotions ran high. As Leader of the Council, David Davies, whose son Merfyn died at Passchendaele in 1917, told the assembled crowd that the 'fallen were with them in spirit that day', his voice faltered and he broke down, unable to continue for some minutes. Colwyn Bay architect Sidney Colwyn Foulkes was chosen to design a 50-foot-high obelisk formed from Cornish granite, topped with a flaming grenade in brass. On Remembrance Day 1922 the memorial was unveiled, attended by weeping mothers and wives, fatherless children and sad-faced fathers of the 212 Llandudno men who had died. Also present were hundreds of veterans and thousands of members of the public. The service was conducted by the rector of Llandudno, Llewelyn Hughes, who had lost one son in the war while another was seriously wounded.

Undeniably, many of the men who survived the war had significantly shortened lives due to bronchial issues and breathing problems caused by gas poisoning, shrapnel wounds that triggered years of intolerable pain, and the mental scars that never healed, all of which are a legacy of the First World War and led to many premature deaths. The survivors are not remembered on the

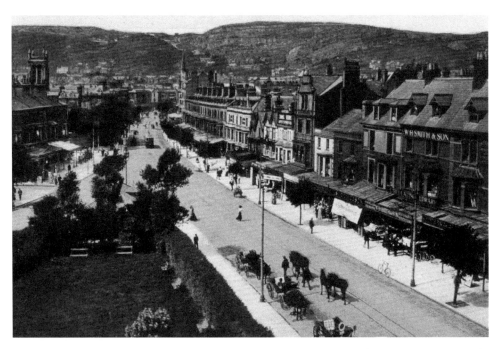

North Western Gardens was the council's preferred choice to site the new war memorial.

town's memorial, nor are the hundreds of other townspeople who contributed – the old men who patrolled the coastline keeping watch for enemy invaders, the nurses who tended and cared for the wounded, and the women who knitted 'comforts' for the troops.

Llandudno's war memorial was funded by public subscription and residents were very generous with donations. With the surplus money a Maternity and Child Welfare Centre was built on Oxford Road. Landowner Lord Mostyn donated the plot of land and the facility was built by Llandudno builder Luther Roberts. Luther's son, Llewelyn, served with the Royal Navy during the First World War and survived the torpedoing of his ship. Llewelyn worked for Cunard-White Star Line in the post-war period and was chief engineer on the ocean liner *Queen Mary* when she set the Blue Riband for the fastest crossing of the Atlantic in 1936. The maternity home was officially opened by Neville Chamberlain, Minister of Health, in November 1926. Councillor Arthur Hewitt handed the future prime minister the key to the front door and he declared the centre open, only to have to repeat the opening minutes later because several photographers had missed the moment. Chamberlain was on good form, joking with the press that the first birth had already taken place as a pair of house martins had raised their youngsters in the eaves of the building. Whereas the war memorial commemorated the past, the new medical facility was a legacy, a hope for a brighter future.

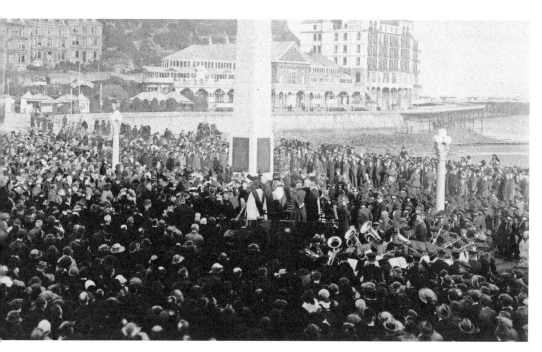

Crowds at the unveiling of Llandudno war memorial in November 1922.

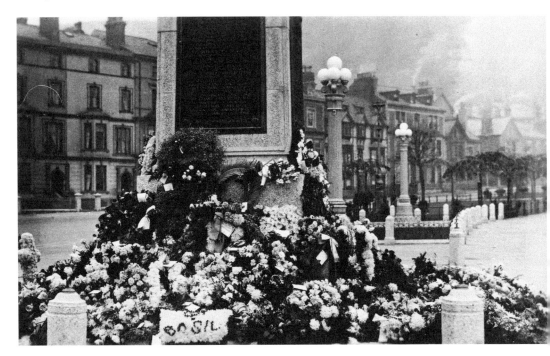

Hundreds of bouquets of white chrysanthemums were placed at the base of the new war memorial including a tribute to nineteen-year-old Basil Hewitson, who died in October 1915.

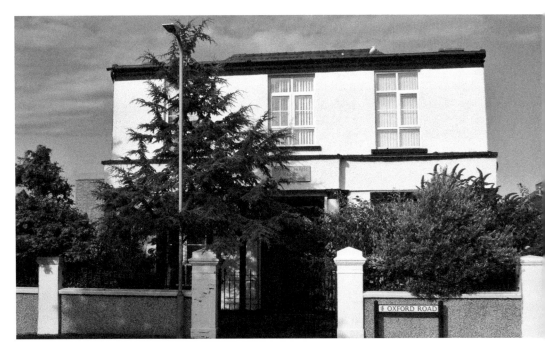

The former Maternity and Child Welfare Centre on Oxford Road.

The Second World War

Thirteen years later Chamberlain was in a far more sombre mood when his mournful tones declared that Britain was once again at war. On 1 September 1939 Germany invaded Poland. Despite the British and French governments giving Adolf Hitler an ultimatum for his troops to leave Poland, he refused. Forty-eight hours later, on the morning of 3 September, a final letter to withdraw was sent to the German leader. When these demands continued to be ignored, Prime Minister Neville Chamberlain promised that Britain would 'fulfil its obligations to Poland', committing the country to a second European war in a generation.

The day that Germany occupied Poland, a blackout was introduced across Britain requiring all light from houses, shops and businesses to be concealed. There was a rush to buy blackout material from stores including Oriental Bazaar, once famed for selling Far Eastern novelties, on Mostyn Street, which asserted they stocked 'all widths at the keenest prices'. Street lamps were turned off, as was the decorative festoon lighting along the promenade and pier. In the first month of the war, road traffic accidents trebled and measures were introduced to reduce casualties on the road with white lines painted on kerbs, bollards and trees by council workmen. Garages were busy too, fitting headlight shades to cars that directed the beam downwards, and orders were issued that no vehicles were to be parked on the promenade at night. Fed up Crosville bus drivers appealed to the public not to shine torches in their eyes but to instead attract attention by reflecting light onto an ungloved hand or newspaper.

Some of the earliest casualties of the war were the colourful birds in aviaries at Haulfre Gardens. This popular attraction captivated locals and holidaymakers alike, charmed by the budgerigars, canaries, red-crested cardinal and talking parrot. Importing millet to feed pet birds was not a wartime priority and as it became increasingly difficult to obtain, the park keeper watched all but the canaries die of starvation.

Protecting the town's populace from aerial attack had been considered by the council since before the Munich crisis of 1938. Rather than build structures, the council believed quarries would suffice and approached landowner Lord Mostyn to utilise two old limestone mines in Happy Valley. It was estimated that 4,000 townsfolk could be accommodated between Elephant's Cave and the hollow formerly used by William Laroche as a photographic studio on Marine Drive. Lord Mostyn's chief agent, G. A. Humphries, provisionally granted permission but requested rent of 2s per year. The council was enraged and wrote to Mr Humphries suggesting that the proposed rent be waived.

In practice, using Happy Valley caves as air-raid shelters was unworkable. Instead, basements of shops and hotels were strengthened and fitted out as refuges while surface shelters were constructed in Prince Edward Square, Bryniau Road and at the rear of King's Road. A further eighty people could be

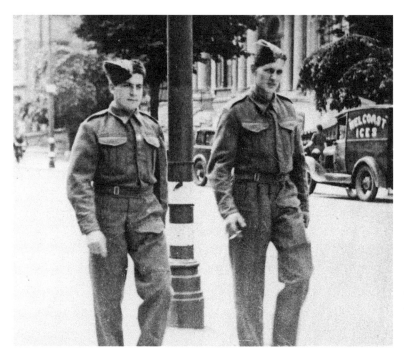

Lamp standards and street furniture were painted with white stripes in a bid to reduce road traffic accidents.

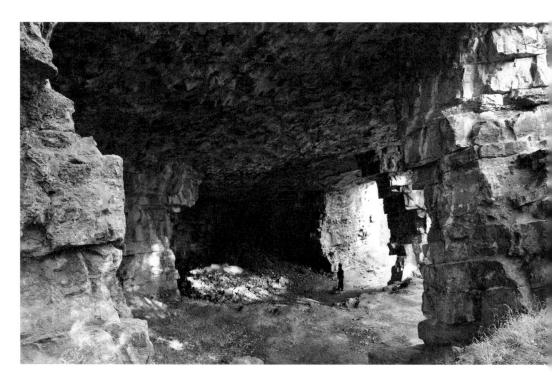

Two limestone quarries in Happy Valley were earmarked for use as air-raid shelters. The council proposed to level the floor and sandbag the entrance of Elephant's Cave (pictured here) and Laroche's Cave.

Laroche's Cave.

accommodated in the underground toilets on lower Mostyn Street, colloquially known as 'Bog Island'. On the Great Orme, the headmaster requested that trenches be dug on the pitch and putt golf course adjacent to his school on Llwynon Road. Elsewhere, emergency ditches were dug in the grounds of Holy Trinity Church and on Gloddaeth Avenue for residents caught in the open during an air raid.

One enterprising local businessman manufactured an indoor air-raid shelter for affluent citizens who preferred not to leave the comfort of their living room at the sound of the siren. Joseph Salzedo of St Seiriol's Road used the 'finest' corrugated steel to construct his £18 16s superior, interior sanctuary, boasting that the metal frame could withstand 4 tons of falling debris. In six years of war Llandudno's air-raid sirens, situated at the electric works on Cwm Road and the fire station on Market Street, sounded fifty-seven times. On the first occasion, in November 1939, householders and shopkeepers ran into the streets as the warning began, gazing skyward into the grey gloom, looking for the Heinkel reconnaissance plane spotted by the Royal Observer Corps. Chief Warden Major Claud Hughes rebuked the public for not taking cover when the alarm rang, warning that most civilian casualties would occur from flying shrapnel and glass. An emergency reservoir, containing 5,000 gallons of water, was erected at the rear of Red Garages' showroom on Vaughan Street for use by the fire brigade if the town was bombed.

Food rationing was introduced in January 1940 and continued until July 1954. Ration books were prepared, initially at the Town Hall and then from the Food Office, Walsall House, on Chapel Street. They were distributed from the schoolroom of the Ebenezer Chapel.

The Llandudno 'Pals'

The Drill Hall on Argyle Road was home to a battery of Royal Artillery Territorials during the 1930s. Commanded by First World War tank hero Lieutenant Colonel Clement Arnold, local men were encouraged to join, persuaded by the regular sporting competitions, the two week-summer camp and an extra shilling or two in their pockets. In April 1939, with war looking probable, the government demanded that the Territorial Army be brought up to full strength – and then doubled. A recruitment drive commenced, urging men to sign up – 1,200 were required from Caernarvonshire alone. To encourage potential recruits to join the colours, a military spectacle was organised. Centred around Llandudno's war memorial, army lorries were exhibited, along with the local battery's howitzers, the muzzles burnished from practice firing. 'Your King and Country need you!' boomed the recruitment sergeants. The rhetoric ramped up further at a meeting in the Town Hall where First World War veteran Alderman Arthur Hewitt exhorted young townsmen to enlist; his speech drew parallels with First World War recruitment campaigns.

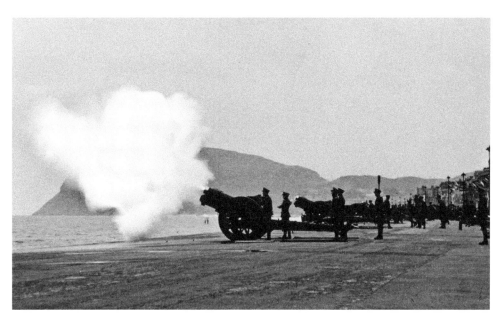

The Royal Artillery perform a twenty-one-gun salute on Llandudno promenade on the occasion of the coronation of George VI and his wife Elizabeth in May 1937.

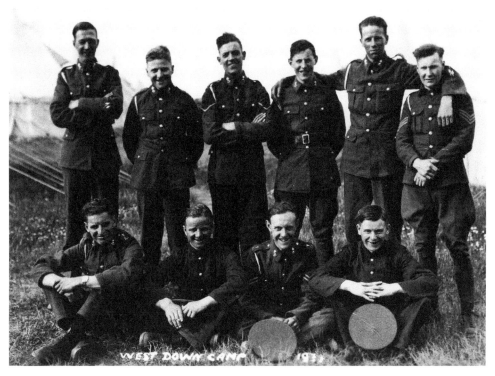

Llandudno Territorials at West Down Camp, Salisbury Plain, weeks before the outbreak of war. (Courtesy of Lalita Carlton-Jones)

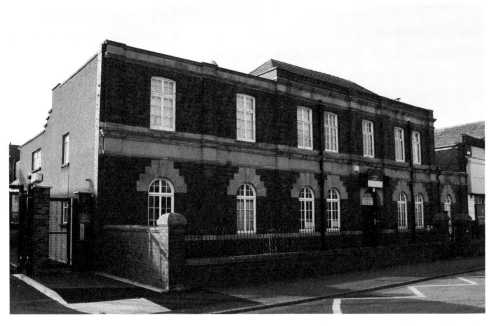

The Drill Hall on Argyll Road was built in the 1920s and continues to be used by the military today.

Perhaps it was the patriotic fervour or the wish to follow in the footsteps of their fathers who a generation earlier had fought in the First World War, but scores of men, many just eighteen years of age, volunteered. In July 1939 the local Territorials were rebadged as the 69th Medium Regiment, Royal Artillery, and the men of Llandudno made up D Troop, 242 Battery.

The part-timers were mobilised in September 1939. Each man was given a medical examination, issued with his kit and paid a £5 bounty. Initially billeted at St Asaph, they later moved to a camp at Chipping Sodbury in Gloucestershire, where they spent the next six months. Training quickened apace with regular visits to the Royal Artillery's instruction school at Larkhill, Wiltshire, calibrating and firing their guns. Back at Chipping Sodbury, a visit from King George VI in February 1940 was a welcome diversion from the monotony of daily life. In April 1940 Lieutenant Colonel Clement Arnold bade farewell to the regiment and was replaced by Lieutenant Colonel John D'Arcy, a veteran of the First World War, who had also seen action at the 1916 Easter Rising in Dublin.

On May Day 1940 an advanced party left Chipping Sodbury for Southampton, with the main body following a week later. After disembarking at the French port of Le Havre they dug in near the Belgian village of Vichte. For the next week they fired at enemy positions during the Battle for the Escaut, as the British Expeditionary Force and their French allies attempted to halt the advancing German war machine along the line of the River Scheldt. They sustained their

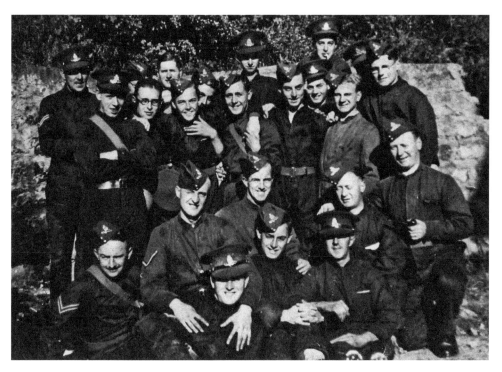

Gunners of the 69th Medium Regiment, Royal Artillery, at St Asaph shortly after mobilisation in September 1939. The Cimatti brothers of Clement Avenue are together on the second row.

first casualty when boatman Kitchener Jones was killed by shrapnel from an exploding shell. The same day a German plane crashed on their position; the pilot was taken prisoner while the observer was killed. Ironically the gunners found that the doomed aircraft contained tens of thousands of propaganda leaflets urging the surrender of the British and French troops. With the Allied position becoming more hopeless by the day, the regiment was ordered to move back: 'Are we retreating Sir?' asked a soldier to Captain, the Earl of Aylesford, the officer in command of D Troop. 'Retreating Hughes? This is a strategic withdrawal!' came the indignant reply.

The Wormhout Ambush

28 May 1940 dawned grey and wet in northern Belgium, a stark contrast to the previous fortnight of sunny weather. The Llandudno gunners were woken early, ordered to spike the howitzers and make for Dunkirk; they had been in France and Belgium for less than three weeks. After destroying the equipment, seventy soldiers of D Troop left the Flemish village of De Klijte in a convoy of four trucks, accompanied by motorcycle dispatch riders. Captain Aylesford was given a prearranged route to the French coast but the situation was chaotic;

British, French and Belgian soldiers choked up the roads along with civilians fleeing the fighting. Amid this confusion Aylesford led his men farther west to avoid the disorder, crossing the French border and driving towards the sleepy village of Wormhout, which he believed was held by the Royal Warwickshire Regiment. They had been tasked to hold the town 'at all costs and to the last man and the last round' to enable Allied soldiers to reach the Channel and be evacuated from the beaches by the Royal Navy. This was not the case. Earlier that day an elite German Panzer SS unit, the Leibstandarte Regiment, had captured Wormhout, sweeping in from the south and east and eventually overwhelming the soldiers from the English midlands. In the town centre the Germans quickly set up machine-gun emplacements on street corners, installed snipers in the tallest buildings and concealed tanks under camouflage nets.

Oblivious, the Llandudno lorries trundled slowly towards Wormhout. On the outskirts, Aylesford ordered the convoy to stop and two officers known to the captain were picked up, much to the displeasure of signaller Ches Hughes, who had to vacate his comfortable seat in the lead vehicle for an uncomfortable ride in the maintenance truck behind. Ultimately, this action saved the life of Bombardier Hughes. As the convoy drove into the centre of Wormhout, the lead vehicle, driven by Gunner Harold Bowen and containing Lord Aylesford, the two unknown young officers and John Coleman, the son of a Llandudno surgeon, took a direct hit from a large calibre German round, engulfing the vehicle in flames and unseating the two dispatch riders immediately behind. Panic ensued

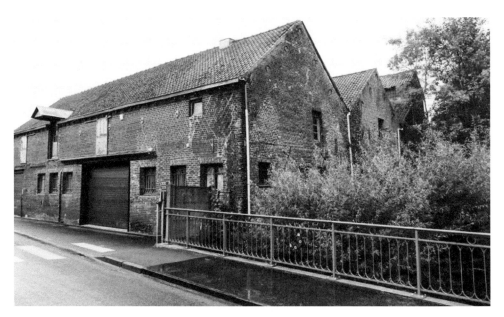

The garage on the banks of La Peene Becque where some of the Llandudno men initially sheltered after the ambush.

among the soldiers in the following three trucks. The months of training had not prepared them for this; they were artillerymen with an occasional rifle between them, having to pitch into battle against a unit of fanatical, well-drilled German troops. The senior non-commissioned officers hollered at the Llandudno men to leave the wagons and run for their lives as machine gun and rifle fire screamed around them. Some took refuge in a garage on the banks of La Peene Becque, a stream running through the centre of the village. They closed and bolted the sliding door behind them but realised that remaining inside was imprudent. A window was smashed, inaudible against the machine gun fire in the surrounding streets, and one by one each dropped into the waterway, their passage obscured by the dense foliage of a grove of weeping willows.

Heading north towards Dunkirk, the Welshmen waded waist deep away from the village and the sound of gunfire gradually subsided. Cold, wet and traumatised, the survivors huddled together below a bridge as the engine from an oncoming vehicle grew louder. Unsure whether it was friend or foe, a soldier tentatively raised his head to find that the approaching convoy was British. With much relief, it was flagged down and they continued their journey to Dunkirk 12 miles away. The actions of Serjeant Major Arthur Steen undoubtedly saved the lives of many men that day. This unsung hero from the Great Orme led some of his young, inexperienced gunners away from danger, one at a time,

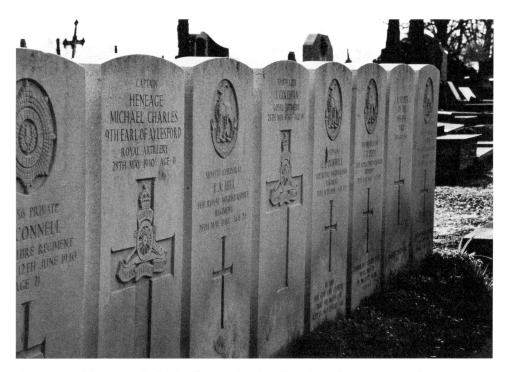

The graves of Captain Aylesford and Lance Bombardier John Coleman at Wormhout cemetery.

past German armoured vehicles and Schutzstaffel troops. While a significant number of D Troop escaped, others were not so lucky. Animal-loving Gunner Tudor Parry of Lloyd Street was sitting in the rear of the third truck petting a young goat when the barrage began. Like others around him, he entered the waterway but instead of heading north, he headed south. Minutes after exiting the stream, he was captured by two SS soldiers and with ninety other British captives was forced marched to a remote cowshed on the edge of Wormhout. Parry later attested that he recognised another gunner at the back of the barn, implying that at least one other Llandudno lad had been apprehended by Hitler's henchmen. What followed was the bloodiest of massacres as the German fighters hurled grenades into the shed full of defenceless British soldiers, shooting dead many others. Shrapnel from one grenade lodged in Tudor Parry's leg and he drifted in and out of consciousness as the executions continued around him. As Parry recovered awareness, a German soldier stood over him and fired a gun at his head, the bullet entering his open mouth and exiting at the back of his jaw. Miraculously, Tudor Parry survived, only to spend the next three years at different German prisoner-of-war camps until he was repatriated in a prisoner exchange scheme. He was scarred for life. Although he gave evidence to a war crimes investigation, no German soldiers were brought to justice for the atrocities at Wormhout.

The replica barn built at the site of the Wormhout massacre to commemorate the murdered soldiers. Since 1988 Llandudno has been twinned with Wormhout.

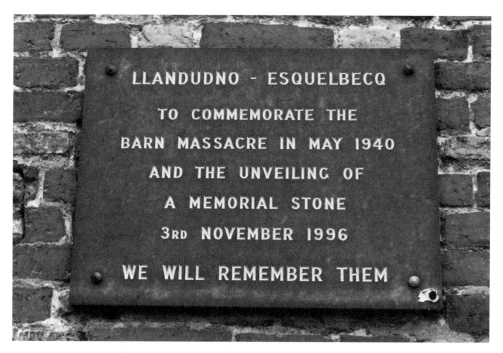

Memorial plaque at Église Saint-Folquin, Esquelbecq, to the Llandudno soldiers killed on 28 May 1940.

Seventeen men of D Troop died at Wormhout, eight from Llandudno. Today it is unclear which died in the initial ambush and subsequent firefight alongside the Earl of Aylesford and which were captured by the SS and murdered in cold blood in the cowshed. As the Germans had stripped the prisoners of identification it was virtually impossible to identify the bodies and thus the five Llandudno men who are listed on Dunkirk's memorial to the missing may also have died in the barn. For those that made it to Dunkirk, the situation did not immediately improve. With their lead officer dead, Second Lieutenant Dehn assumed command of what remained of D Troop and led them to a brickyard behind the sand dunes at Bray, the designated rendezvous point for the regiment. For the next two days and nights the men awaited rescue. They were hungry, tired and in constant danger from marauding Luftwaffe aircraft that strafed and bombed the beaches incessantly. Bombardier George Griffiths of Cwlach Street described how the German 'planes "came over like flies" and that the "sky was black with them"'. There was one Llandudno casualty while the artillerymen were waiting to be removed from the beaches. Arthur Cimatti of Clement Avenue died as he dug a slit trench in the sand; the thirty year old's brother, in the same regiment, survived.

With over 338,000 troops rescued from Dunkirk and landed at ports across the south coast of England, it is unsurprising that it took a few days for the soldiers of the 69th Regiment to regroup. They were gathered together at Bulford Camp

on Salisbury Plain before spending two nights in Colwyn Bay and then moving to Coed Helen on the outskirts of Caernarfon, a former First World War tented encampment. Finally, they were permitted leave. A short sojourn to the Isle of Man followed, preparing and manning defensive positions around Ramsey before returning to the mainland and the Sussex coast where they remained until May 1941. Here they manned coastal defences and were responsible for a stretch of coastline from Hove to Worthing. They also operated anti-aircraft guns around Ford Aerodrome that was heavily bombed in August 1940, killing seven men from the regiment.

At the end of July 1942, the regiment left the port of Liverpool aboard the requisitioned transatlantic liner RMS *Samaria*, their destination Egypt. As they sailed along the north Wales coast the gunners glimpsed the twin limestone headlands of the Great and Little Ormes, for some the last time they would see home. The voyage took seven weeks, sailing via Freetown and Durban, disembarking at the latter and camping on the city's racecourse. To relieve the boredom, the troops formed, the 'Good Company' concert party, which toured the decks and gave a final performance in the officers' mess the night before disembarking at Suez in September 1942. They arrived in Egypt to take part in the epic bombardment at the second Battle of El Alamein, taking up a position on the Springbok Road, 2 miles south of El Alamein railway station. In the opening barrage, the Llandudno lads fired 1,200 rounds, raining terror onto the Afrika Korps. In reply not a single German shell landed on the 69ers' position. When morning came there was no respite. Exhausted and deafened, they were ordered to move forward 6 miles to a new position. Crossing a German minefield, they sandbagged the bottom of their lorries to offer some protection against potential explosive devices. On Guy Fawkes night 1942, the regiment again shelled German positions. Troop Commander Captain Taylor went forward on reconnaissance and returned with armfuls of German and Italian 'souvenirs' and news that the enemy lines had collapsed. At daybreak the regiment witnessed absolute carnage and a battlefield littered with the dead. The living surrendered in their thousands.

Christmas 1942 was spent in the desert and in the New Year two more Llandudno men were killed. Francis Meredith of Taliesin Street was wounded when his position was attacked by a squadron of Stuka dive bombers. Frank died two days later in the back of an ambulance as he was being moved to a field hospital and is buried at Tripoli war cemetery. The following month, Bill Steen, the older brother of Arthur, the unsung hero of Wormhout, was fatally wounded by his own gun and died. On May Day 1943, three years to the day since the regiment was mobilised from Chipping Sodbury, the battery was again in action, supporting Free French forces at Enfidaville. This was their last engagement in North Africa. After a short, well-earned rest, the regiment was back in action in Italy in September 1943 helping to repel the German attack at the frail beachhead

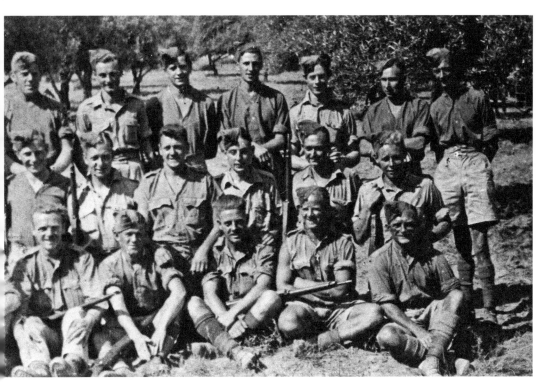

The 69ers in an olive grove in North Africa, two days after the Battle of Enfidaville. (Courtesy of Bob Hughes)

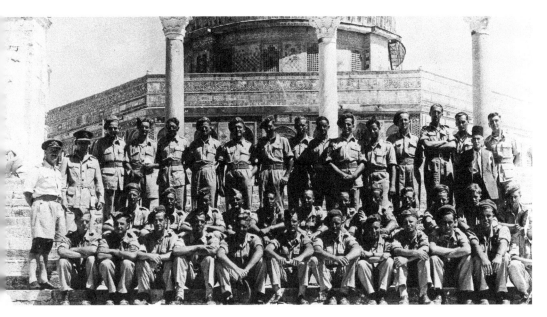

Llandudno gunners at the Dome of the Rock, Jerusalem, July 1944. (Courtesy of Bob Hughes)

of Salerno. More fierce fighting followed and they distinguished themselves at the river crossings of Volturno and Garigliano. There was no let up, taking part in the first two abortive attacks on Monte Cassino, before being taken out of the line and sailing for Palestine for six weeks in July 1944.

In April 1945, the regiment sailed to Marseille and moved up through France, skirting Paris and crossing the Belgian border where they were billeted in a large school at Turnhout. Most hoped that their war was over and they were enjoying the entertainments in this newly liberated town when orders came through to pack up and move out to Dunkirk. Passing through the same towns, including Wormhout that they had retreated through in May 1940, and on reaching the French port dug in and fired on German positions. On 7 May whispers circulated among the local population that 'la guerre est finie' – 'the war is over' – a rumour that was confirmed the following day. After Dunkirk the battery was posted to the north and west of Germany where they undertook guard duties at prisoner-of-war camps before demobilisation began in November 1945.

Guinea Pigs

Llandudno played host to many thousands of evacuees during the Second World War and unlike in many other Welsh towns the displaced were not children, but adults. Plans were drawn up to move vital government departments out of London to the provinces if war came and seaside resorts on the north Wales coast, with an excess of vacant accommodation, were obvious choices. The Inland Revenue was sent to Llandudno. Seafront hotels were requisitioned for office accommodation days after war was declared, forcing hoteliers to put all the furniture and chattels into storage. The Imperial Hotel became the headquarters of the exiled Inland Revenue, where senior officials including Sir William Diggines, the Chief Inspector of Taxes, had their offices. The first 500 staff from Somerset House arrived in February 1940 on specially chartered trains that brought not only personnel, but the hundreds of tons of files and paperwork necessary for a fully functioning government department. The man tasked with arranging living accommodation for the civil servants was the Billeting and Welfare Officer, James Callaghan, who would become Labour prime minister in the 1970s. To many landladies the civil servants were known simply as 'guinea pigs' on account of the one Guinea a week they paid for board and lodgings. By autumn 1940 over 4,000 civil servants were calling Llandudno home and many brought their families, putting an extra burden on schools. At the beginning of the school term in September 1940, an additional 287 children had enrolled at John Bright Grammar School and, for a short time, a two-shift system was introduced with local children attending in the morning and London youngsters in the afternoons.

The Ormescliffe and Crescent Hotels were converted into recreation centres with numerous facilities for the civil servants. Membership cost tuppence a week

Clerical assistant Peggy Humphries (on the right) arrived from London in September 1940 and was billeted with eleven other young women in a hostel on Lloyd Street. She worked at the Estate Duty Office, centred in the St George's Hotel, and her first task each day was to 'connect' the morning's post to the correct office. (Courtesy of Margaret Verena 'Peggy' Jones née Humphries)

and was an ideal place for staff, a long way from home, to socialise and make new friends. Clubs and societies were formed, sports tournaments arranged and theatrical groups established. In the lounge, members of the photographic society exhibited their work. Rooms were set aside for female civil servants to do their washing, clothes mending and ironing while male employees were catered for with an 'odd job' area where they could partake in practical hobbies such as carpentry and fretwork. Interestingly the furnishings in the Crescent Hotel came from luxury passenger liners requisitioned as troopships at the outbreak of war.

A more unusual purposing of the centrally heated areas of the hotel was to dry plant leaves. In March 1942 a meeting was convened at the University College of North Wales, Bangor, to hear a representative of the Vegetable Drug Committee speak about the need to collect plants for medicinal and industrial uses in wartime. Subcommittees were formed across Caernarvonshire, with Miss Raisbeck of Charlton Street responsible for Llandudno. As children made enthusiastic collectors, schools were approached as were the civil servants of the Inland Revenue. Foxglove leaves were collected and used in the production of drugs to treat heart disease while chlorophyll was extracted from nettle leaves and used to dye khaki uniforms. Before being packed and sent to manufacturers the foliage was dried on wire racks in dedicated drying rooms established at the Ormescliffe Hotel where 3 lbs of nettles and 18 lbs of foxglove leaves were dehydrated and dispatched in autumn 1943 alone.

Civil servants printed an in-house periodical, *The Ormescliffe Gazette,* until compelled to cease publication under the Paper Control Order in November 1941.

The Banjo Club and Operatic Singers were just two of the many clubs and societies formed by the Inland Revenue while in Llandudno.

The Craigside Hydro was requisitioned by the Special Commissioners of Income Tax. Around 600 civil servants were based in the hotel with a further 600 clerks housed in the tennis courts on the opposite side of the road.

At the end of the war there was deep resentment among a large proportion of the civil servants that they had not returned to London and staged a mass protest at the Arcadia Theatre to show their displeasure. One reason for the delay in leaving north Wales was that instead of returning to Somerset House, the government decided to relocate individual departments of the Inland Revenue to different parts of the country to create well-paid employment outside of London. At the same time hoteliers were keen to be rid of the 'demanding' civil servants who were occupying bed space. Llandudno Hotels Association estimated that the town was losing £600,000 a year in potential earnings from visitors. Slowly, they did leave. In May 1947, 600 staff from the Estate Duty office left for Harrow, allowing the St George's, Trevone, Elsinore, Somerset, Wavecrest and Tikvah hotels to be refurbished and reopened to holidaymakers. As the special trains steamed out of the station, the remaining 300 civil servants gathered on the station concourse to stage another noisy demonstration demanding their repatriation to southern England. It was not until autumn 1948 that the last of the civil servants left when the Departmental Claims Branch vacated the Hydro Hotel for Cardiff. While hoteliers were pleased that the civil servants had left, there was regret for many as 600 local people had been temporarily employed as secretaries and clerks with the Inland Revenue and were left jobless.

64

BBC and Entertainment

In September 1939 all places of amusement were closed, ordered to by a government fearing mass casualties if a theatre, cinema or sports stadium was struck by an enemy bomb. Within two weeks this decision was reversed and entertainment venues reopened albeit without the gaily coloured external lighting that remained blacked out until November 1944. The only Llandudno venue closed for the duration of the war was the Pierhead Pavilion, which was inaccessible anyway from May 1940 after timbers on the pier were removed for fear of the structure being used during a German invasion.

In line with moving principal institutions out of London, the BBC Variety Department relocated to Bristol in 1939 but when the West Country city attracted the attention of Goering's bombers a new home was demanded, and with some urgency. In February 1941, they headed north on a special train from Bristol laden with comics, crooners, musicians, actors and technicians and took over the County Theatre in Bangor and the Grand Theatre in Llandudno. One of the first broadcasts from Llandudno featured Canadian-born organist Sandy Macpherson, who devoted the entire programme to the people of the town. Other popular shows broadcast from this venue included ITMA – It's That Man Again – starring Tommy Handley and Ted Kavanagh. When the BBC arrived in north Wales, they were short of both equipment and skilled engineers because many of the

The Grand Theatre was taken over by the BBC Variety Department in 1941. It reopened to the public in February 1946 after being leased to Bernard Delfont, a leading Russian-born British theatrical promoter.

latter had been called up into the Royal Signals. In Llandudno they turned to local supplier Bill Sargent, who dealt in wireless sets and public address systems from his shop on Madoc Street. As well as his payment, Bill was given tickets for the shows and suddenly found himself the most popular man in Llandudno! After the BBC left the Grand Theatre it was occupied by the American army as a garrison theatre and later by a British military unit for storage.

A performance by George Formby on a Sunday in September 1940 landed theatre impresario Will Catlin in hot water for bringing the sanctity of the Sabbath into question. As licensee of the Arcadia Theatre, Catlin was summoned to appear in court charged with permitting music that was not of a 'sacred and/or classical nature'. In the audience were two police officers who listened as cheeky comedian Formby sang some of his most popular songs including 'Chinese Laundry Blues', 'When I'm Cleaning Windows' and 'Leaning on a Lamp Post'. These were deemed to be of 'the Saturday night class' and in court magistrates found the case proven, but owing to Mr Catlin's previous good record they dismissed the proceedings on payment of costs.

For eight consecutive nights in May 1941 the Luftwaffe bombarded Liverpool, Birkenhead, Wallasey and Bootle with hundreds of thousands of incendiary and high-explosive bombs. Over 1,900 people were killed and countless more injured. As key ports, Liverpool and Birkenhead were prime targets. Every

Tommy Handley, star of ITMA – 'It's That Man Again'. After the BBC relocated to north Wales, and the seaside, producers renamed the next series ITSA – 'It's That Sand Again'.

AT THE PIER PAVILION

Week Commencing—

Monday, April 28 Welcome return of THE REGENCY PLAYERS.

" May 5 THE REGENCY PLAYERS in Repertory.

" " 12 THE SADLERS WELLS OPERA COMPANY.

" " 19 EMLYN WILLIAMS in "THE LIGHT OF HEART"

" " 26 BARRY K. BARNES and DIANA CHURCHILL in
 " ON APPROVAL."

" June 2 JOHN GIELGUD in " DEAR BRUTUS."

" " 9 " THE CHOCOLATE SOLDIER."

" " 16 Company as booked.

" " 23 NORMAN GRIFFIN in " MR. CINDERS."

LLANDUDNO ADVERTISER LTD

ENTERTAINMENT IN WAR-TIME IS MORE OF A
NECESSITY THAN IN PEACE.

THE
PIER PAVILION

(Proprietors THE LLANDUDNO PIER CO., LTD.)
General Manager & Secretary T. TURNER PILLING
— 'PHONE 6 2 5 8 —

Thursday & Saturday, April 10th and 12th,
and Week Commencing April 14th

Nightly at 7-30. Matinees Easter Monday, Wednesday & Saturday at 3-0

CLARKSON ROSE

PRICES OF ADMISSION (Including Tax) :
Reservable Orchestra Stalls 3/6
Reservable Stalls & Circle 2/9
Unreserved Stalls, Circle & Balcony 2/- & 1/3

THE PIER PAVILION IS LLANDUDNO'S LEADING
ENTERTAINMENT CENTRE.

GO TO IT!

Wartime programme reminding the public not to feel guilty about attending the Pier Pavilion. After all, 'Entertainment in wartime is more of a necessity than in peace.'

week hundreds of merchant vessels docked in the River Mersey bringing vital supplies of food, raw materials and military hardware. After the raids, fires raged across the region that could be seen burning in the night sky from as far away as Llandudno. Firefighters from across north Wales were sent to Merseyside to help extinguish the flames and to rescue helpless people from the rubble. To raise funds for the victims of the Merseyside Blitz, a committee was formed in Llandudno and a concert organised at the Pier Pavilion. Rival theatres agreed to close for the evening and provided acts for the show. From the Happy Valley stage came Charles Wade and his Follies, from the Arcadia comedian Charles Harrison and from the Palladium soprano Kathleen Batters. The finale to the evening's entertainment were comedians Harry Korris, Robbie Vincent and Cecil Frederick, better known as Messrs Lovejoy, Enoch and Ramsbottom from the hit BBC radio show *Happidrome*.

By 1942 holidaymakers, encouraged only to make essential journeys in the early years of the war, started to return to Llandudno and arrived in such large numbers, particularly on bank holidays, that many were forced to sleep on deck chairs in the Town Hall as no other accommodation was available.

Merseyside Air Raid Distress Fund

CONCERT

To be held in

THE PIER PAVILION
LLANDUDNO

(Kindly loaned by the Directors).

on

SUNDAY, JUNE 8th, 1941,

**PLEASE GIVE GENEROUSLY
FOR THIS PROGRAMME,
THE MINIMUM PRICE
OF WHICH IS**

3d.

ENTIRE PROCEEDS IN AID OF LIVERPOOL'S AIR RAID
DISTRESS FUND

Merseyside Air Raid Distress Fund programme.

Coast Artillery School

Shortly after the collapse of France in June 1940 and the evacuation of the British Expeditionary Force from Dunkirk, there was considerable expansion of coastal artillery and new batteries were raised to counter the increased threat of invasion from Germany. It became apparent that it would be impossible to continue to train personnel at the Royal Artillery's Coast Artillery School at Shoeburyness on the Thames Estuary due to a lack of space and increasing enemy activity. The school was forced to relocate, and Llys Helyg Drive on the Great Orme was the preferred location of Brigadier Bernard Court-Treatt, its commandant. He considered it ideal for several reasons: good anchorage for target vessels, restrictions for firing and night practice were non-existent, and the Great Orme offered a perfect location for training in radar that was being developed by coastal artillery. Following a site meeting with representatives of the War Office, Royal Artillery and Royal Engineers, construction was awarded to civil engineers McGeogh Ltd of Liverpool, by virtue of being the only tender received. The school became operational in September 1940 and offered courses in gunnery, searchlight operation, wireless and radar. It is estimated that 20,000 cadets passed through the training facility in the five years it was in Llandudno.

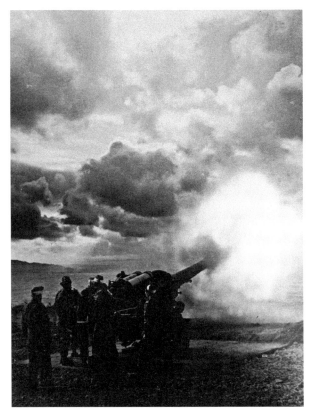

Cadets loading a naval gun. These were fired at targets from a range of 8,000 yards. (Courtesy of Jennifer Britton)

Soldiers fired at both static and moving seaborne targets. The permanent target was moored off Ynys Seiriol (Puffin Island) and was an ex-workhorse of the merchant fleet. The SS *Gambhira* was sold for scrap in 1939 but acquired by the Admiralty only to be sunk as a blockship at Scapa Flow, a countermeasure to stop German submarines entering this vital Royal Navy anchorage in Orkney. She was raised in 1943 and towed to Conwy Bay only to be sunk again in October 1943 by artillerymen on the Great Orme firing the 9.2-inch naval gun. Meanwhile, high-speed motor torpedo boats (MTBs) and launches, towing targets mounted on floats, sped around Conwy Bay for gunners to shoot at. Made of canvas and wood, some of these screens were constructed by local builder Frank Tyldesley at his Craig-y-don works. As an aside, an MTB was responsible for damaging one of Llandudno's best-known landmarks. During a storm the vessel lost its engine and drifted onto the north shore, capsizing opposite the Imperial Hotel and destroying the diving platform on the beach. Llandudno lifeboat *Thomas and Annie Wade Richards* came to its aid, taking the crew ashore while a large crowd watched from the promenade. For realistic anti-aircraft training, remote-controlled planes, known as 'Queen Bees', took off from Tŷ Croes Artillery Camp on Anglesey and flew across Conwy Bay for the gunners to aim at.

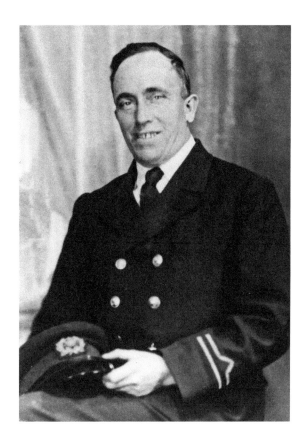

One motor launch was captained by local boatman Vic Meddings, a fisherman selling his catch from the family shop on Brookes Street. When not towing targets for soldiers to take potshots at, he took many of them out for a spot of night fishing aboard his Deganwy-moored boat *Nelly*. (Courtesy of Netta Shirley)

Thirty minutes before firing commenced red flags, or red lights at night, were hoisted by the West Shore toll house, Deganwy Lido and on the summit of the Little Orme to warn the public of the imminent danger. Aircraft were warned by a large letter 'A' painted in black on a white background on the lower slopes of the Great Orme. Byelaws introduced in 1942 prohibited the public from collecting bullets, shells or other projectiles – with fines of £5 for anyone caught.

Troops were not billeted on site but at various properties requisitioned around Llandudno. The administrative headquarters were at the One Ash Hotel on Gloddaeth Street where many of the staff were women of the Auxiliary Territorial Service. In May 1940 they were visited by Princess Mary, in her capacity as chief controller, who joined them for a meal in the dining hall. The senior officers' mess was located at the now demolished Gogarth Abbey Hotel, junior officers' messes were at the Richmond and White Heather Hotels while Red Garages was taken over as a workshop to service the gun barrels and as a dining hall for other ranks.

COAST ARTILLERY SCHOOL.

PROGRAMME OF PRACTICE SEAWARDS for week commencing Monday, 30th June, 1941.

Date	Time	Nature	Remarks
Monday 30.6.41.	2 p.m. to 5 p.m.	6-pr. twin.	Two M.T.B. Targets. No. 1 Area Closed.
Tuesday 1. 7.41.	9 a.m. to 5 p.m.	6-inch	Two M.T.B. Targets and one H.S. Target. Nos. 1 and 2 Areas Closed.
Wednesday 2. 7.41.	9 a.m. to 5 p.m.	SPARE DAY for 6-inch.	Two M.T.B. and one H.S. Targets. Nos. 1 and 2 Areas Closed.
Thursday 3. 7.41.	10.30 a.m. to 7 p.m.	6-inch 4.5-inch.	Three H.S. Targets. Nos. 1 and 2 Areas Closed.

E.J. Weller.
S.M. (I.G.),
for Major, G.S.,
Coast Artillery School.

LLANDUDNO.
28th June, 1941.

Firing orders for the Coast Artillery School, June 1941.

Cadets and instructors in the grounds of Gogarth Abbey Hotel. (Courtesy of Jennifer Britton)

Squatters

In September 1945, the Coast Artillery School left for the Citadel in Plymouth, but the abandoned buildings on the Great Orme – still known locally as the 'gun sites' – were soon occupied by families unable to find any suitable living accommodation. Many who moved into the former military camp were recently demobilised servicemen resentful at the lack of available homes having, in many cases, given up a house in Llandudno to fight in the war.

The first family to occupy the site was Thomas Barr, his wife and two daughters. They were rendered homeless in the Clydebank Blitz of 1941 and had been living with two other families in Llandudno Junction, twelve of them sharing three unfurnished rooms. Despite the nearest water being 100 yards away, cooking on a paraffin stove and suffering the bitter cold in windowless buildings, the Scotsman argued that it was still better than his previous lodgings. Word got around and within a few months the majority of the buildings were occupied. Despite efforts by Llandudno Urban District Council to evict the squatters, they relented, allowing the trespassers to stay and charging rent of 8s 6d per week. Eventually, prefabricated and council houses were built in Llandudno and the 'gun site' community left. Their former dwellings at the Coast Artillery School were mostly demolished in the 1950s.

The remaining 'gun site' buildings have been scheduled by the Welsh Government as a site of national importance.

Little Orme Practice Camp

In July 1941 the War Office gave the Royal Artillery permission to open a practice camp on the Little Orme. The land was requisitioned from Lord Mostyn and operational by March 1942 for the first batteries to practice seaward firing. The limestone quarry in which the camp was built had not been worked since 1935 and was an ideal location with good access from the main road, a suitable height above sea level and was well removed from the civil population, ensuring that firing was unlikely to cause annoyance. No troops were permanently based at the practice camp, so four properties initially commandeered by the Royal Army Service Corps were taken over by the staff. These included Villa Marina on Colwyn Road and Moorcroft on Fferm Bach Road. Visiting troops stayed at Hadden Croft and Arnhall, the now demolished mock-Tudor house built for the Tate and Lyle sugar family on Bryn-y-bia Road.

For a couple of years after the war the camp became the permanent home of 30 Coast Battery (Roger Company) and although firing was limited to fifteen times a year, residents complained of the excessive and intrusive noise that they accepted as necessary in wartime but questioned its necessity in peacetime.

Observation post on the Little Orme with panoramic views along the north Wales coast.

RADAR

An estimated 600,000 people visit the Great Orme annually, drawn by its natural beauty, panoramic views and countless attractions. However, few visitors realise the importance and significance of the 700-foot-high limestone headland during the Second World War. Its elevated and geographic position has long made it the ideal location for communications equipment and even today there is a proliferation of aerials, dishes and antenna at the summit. The first documented evidence of a lookout atop the Great Orme was during the Napoleonic Wars of 1803 to 1815 when combustible materials were collected and readied to signal of the enemy's approach. One day a foreign vessel was observed making for an anchorage in Llandudno Bay, the alarm was given, and locals armed themselves with sticks, pitchforks and blunderbusses. Happily, the ship had only run into land to obtain a supply of fresh water. In 1841 a semaphore station was built on the summit as part of the Liverpool to Holyhead telegraph system.

At the turn of the twentieth century 160 acres of rough farmland was transformed into a golf course, with the old semaphore station utilised as the club house. This was demolished to make way for a hotel that opened in 1909 and was requisitioned by the RAF during the Second World War as a Chain Home Low

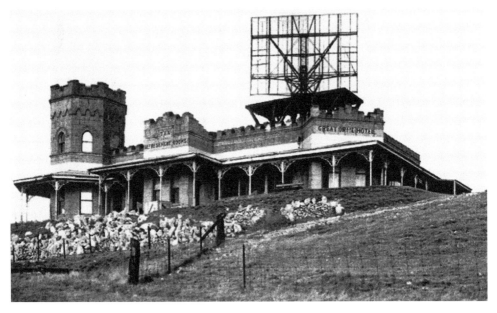

The Great Orme Hotel was requisitioned by the RAF during the Second World War as a Chain Home Low radar station.

American serviceman Louie Schmitt from St Albans, New York, visited Llandudno in June 1945. (Courtesy of Ronnie Jones)

radar station. With its unique antenna, this Air Ministry experimental station monitored both aircraft and surface vessel movements until its removal in 1946. Known as RAF Great Orme's Head, personnel regularly complained of the inclement weather and unserviceable equipment. Their only protection against an enemy onslaught from the air was a pedestal-mounted Browning machine gun that they took pleasure in practice firing towards Bishop's Quarry. Despite the barbed wire entanglements that surrounded the complex, schoolchildren used this vantage point to watch convoys of merchant vessels assemble offshore, awaiting escort ships to chaperone them across the Atlantic.

On the western side of the headland, close to the Rest-and-be-Thankful café, is a concrete road known as the 'tank tracks' on account of its corrugated surface. In January 1943, Air Defence Research Development Establishment (ADRDE) moved their research operations from Steamer Point near Christchurch on the Dorset coast to this site on the Great Orme. The facility, which cost over £25,800 to build, was substantial, arranged over two storeys with a scanner mounted on the roof. Some forty scientists were employed at the site, often working seventy hours a week. Radar is a detection system that uses radio waves to ascertain the range, angle and speed of an object. While still in its infancy, it was of paramount importance for the war effort and its significance cannot be underestimated. At ADRDE the range and accuracy of radar sets were tested and trials to detect objects of differing sizes including planes, ships and ordnance completed. Aircraft from local airbases regularly took off to be tracked and intercepted by radar operators on the Great Orme, as was the luxury yacht *Llys Helig*, which left her pre-war mooring on the River Conwy to spend the hostilities sailing between the Menai Strait and Llandudno. The boffins at ADRDE were assisted by two other experimental

Plaque commemorating all who served at RAF Great Orme's Head while it was operational.

A radar installation above St Tudno's Church, Great Orme. Guards at the site regularly sheltered within the church during inclement weather.

Telecommunications Research Establishment (TRE) operated from a facility where the Rest-and-be-Thankful café is today.

stations: Coast and Anti-Aircraft Experimental Establishment (CAEE) and Telecommunications Research Establishment (TRE). CAEE headquarters were at the requisitioned Victorian house, Bryn Estyn, on Albert Drive in Deganwy with installations at Conwy Morfa and on the Great Orme.

Defending Llandudno

The Home Guard is an object of fun in the television comedy *Dad's Army*, but it was important to domestic security during the war. In May 1940 the Minister of War, Anthony Eden, announced on the wireless the formation of the Local Defence Volunteers (LDV) when the perceived threat of invasion was at its highest. The LDV was for men who were too young or too old to join the regular army or worked in reserved occupations, and many were veterans of the First World War. Some wags named the LDV – 'Look, Duck and Vanish'. Winston Churchill renamed them the Home Guard.

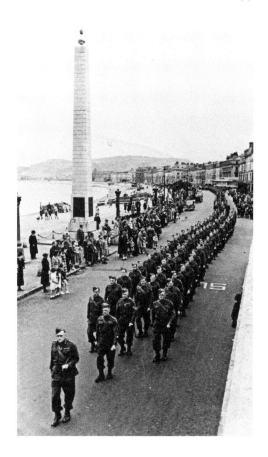

Major P. E. Taylor leading B Company of the Home Guard past Llandudno war memorial. The image was taken from on top of the air-raid shelter in Prince Edward Square. (Courtesy of Idris Owen)

First to enrol in Llandudno, minutes after the broadcast, was Jack Owen, a Crosville bus driver whose garage was opposite the police station where registrations took place. He had seen action in the First World War serving with the Machine Gun Corps and been wounded twice. Within a week, over 400 men had volunteered, including hundreds of civil servants billeted in the town with the Inland Revenue. Known as the 5th battalion, Caernarvonshire Home Guard they were commanded by Lieutenant Colonel William Lester whose day job was Chief Collector of Rates for Llandudno Urban District Council. He had served with the Royal Welsh Fusiliers during the First World War, serving in France, Germany and Ireland. The headquarters was at the Irish Linen Warehouse in St George's Place. Two weeks after its formation the first patrol took place on the Great Orme; with no uniforms or weapons, they improvised with stout sticks and golf clubs.

Primarily the Home Guard's duties were to patrol the area for enemy parachutists and report the landings. Lookouts and patrols were posted at elevated vantage points including on the Great Orme and Bryniau Mountain, universally unpopular in bad weather. To counter this, enterprising members of the platoon carried a beach bathing hut to the summit of the latter, with 2,000 sandbags

Caricature of the officers and senior non-commissioned officers of Llandudno Home Guard. Sergeant Major Thomas Owen, known as Tommy Sumner on account of being employed by Sumner's Restaurant since he was a boy, is pictured sat on the drum.

to stop it blowing away. They failed, and the wheeled timber structure did not survive a particular stormy night and was replaced with a stone shelter. At Maesdu Farm the battalion built an assault course, rifle range and stores. In April 1943 an audacious raid took place at the depository when hand grenades, mortar bombs, a sticky bomb (an ad-hoc anti-tank grenade), rifles, a revolver and a quantity of ammunition was stolen. The police swiftly arrested the culprits: three Llandudno schoolboys, a sixteen-year-old civil servant working at the Inland Revenue and a Dutch national. All were charged with arms trafficking. The ordnance was found secreted around one of the boy's homes; grenades were found on each side of the pendulum in the back of a mantel clock and three in a chicken coop in the back garden. The guns and ammunition had been sold to Derek de Vries, a Dutchman invalided out of the Royal Netherlands Army living in Gyffin, near Conwy. De Vries was sentenced to nine months imprisonment, the sixteen-year-old was bound over for twelve months and the three schoolboys received severe reprimands.

Both the Home Guard and the Inland Revenue had pigeon lofts in Llandudno in the event that communications failed. An avian casualty of the war was the peregrine falcon, which bred in small numbers on the Great and Little Ormes. Described as the Messerschmitt of the bird world, they were denounced as being unpatriotic for killing the valiant message-carrying pigeons. Under the Destruction of Peregrine Falcons Order 1940 it was lawful for authorised persons to destroy the raptor and appeals were made to the people of Llandudno to disclose nest sites.

By June 1940, much of western Europe was under the Nazi jackboot – and Britain stood alone. As Neville Chamberlain resigned and Winston Churchill became prime minister there was also a change at the top of Britain's home defences. General Ironside was put in charge, responsible for building anti-invasion

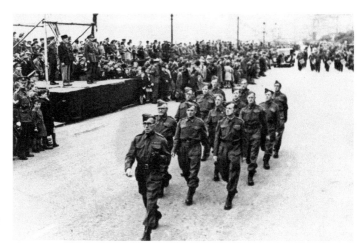

Llandudno Home Guard, May 1944. This was the first time an American officer had taken the salute at Llandudno's annual Civic Parade. (Courtesy of David Kyffin)

defences and commanding troops in the event of German landings. In response a series of 'stop lines' were constructed around the country. These defensive lines used natural obstacles and geographical features, such as mountains and rivers, along with man-made barriers including pillboxes, anti-tank devices, trenches and barbed wire entanglements, to halt the advancing enemy. While the short hop across the Channel was the most obvious direction for a German attack, it was important that every eventuality was prepared for, including attack from the west through neutral Ireland. In Llandudno pillboxes were constructed at West Shore, Penrhyn Bay and at Maesdu Golf Club. The loopholes are still visible today. Plans to build seven reinforced concrete machine gun emplacements on North and West Shores and on Marine Drive were drawn up, including one on the town's bandstand. Such was the paranoia of the authorities that Llandudno Publicity Association had aerial pictures of the resort censored in their 1940 tourist guide.

The only bombs to fall on Llandudno did so in the early hours of the last day of May 1941. Undoubtedly jettisoned by a Luftwaffe bomber heading to, or returning from, Liverpool, they landed harmlessly in the Craigside area. One of the bombs landed on the beach close to the Craigside Hydro pumping station while the other two fell on Nant-y-Gamar, slightly damaging the smallholding Penmynydd. German aircraft regularly took off from airfields in northern France, following the Irish coast to Dublin before turning east along the north Wales coast to Merseyside.

The danger did not just come from the air but from the sea too. Magnetic sea mines occasionally drifted into Llandudno Bay and the Home Guard was summoned to the promenade to secure the area from curious bystanders. One device washed up between the paddling pool and the Little Orme and before the police, civil defence services or Home Guard arrived, youngsters thought it amusing to throw stones at it to see what would happen – fortunately without

Stepped embrasures, enabling a wide field of fire, were built into the wall of Maesdu Golf Club for the Home Guard.

The only evidence of the German bombs that fell on Llandudno in May 1941 is a small crater. The incident caused great excitement among local schoolboys who rushed up the hill the following morning in a bid to gather shrapnel.

incident. Another floated onto the beach opposite the Washington Hotel, forcing the authorities to close the area off and evacuate hundreds of civil servants from their offices in seafront hotels.

The Sandringham Hotel

In July 1940, Lever Brothers, the world-famous soap manufacturers, purchased The Sandringham Hotel on the West Shore as a recuperation and rest centre for its employees. Its staff magazine reported that the company recognised 'the need for rest and relaxation for those suffering from mental strain as a result of war conditions, and the difficulty of finding suitable accommodation in a safe area at the present time'. Staying at the hotel was free of charge for employees suffering from

The Lilly
Restaurant,
formerly the
Sandringham
Hotel, at West
Shore.

Fire guards
and firemen at
Lever Bros Port
Sunlight
Works, 1944.

strain who were recommended by the company's medical officer. Lever Brothers was well known for taking an interest in the welfare of its employees, as evidenced by the model village of Port Sunlight, adjoining its soap factory on the Wirral.

Women's Land Army

At the outset of the Second World War the United Kingdom imported 69 per cent of all food requirements, mainly from the Dominions and the Americas. Fearing food shortages, the government demanded that previously uncultivated land be brought into production and this mandate led to public spaces and sports pitches being ploughed up. Greens on the golf course at the summit of the Great Orme were turned over to potato production, and pupils from John Bright Grammar School were among the volunteers who brought in the harvest. The government encouraged the public to be more self-sufficient and grow their own vegetables during the 'Dig for Victory' campaign. In Llandudno 50 acres were made available for allotments including the promenade flower beds where children were encouraged to grow food.

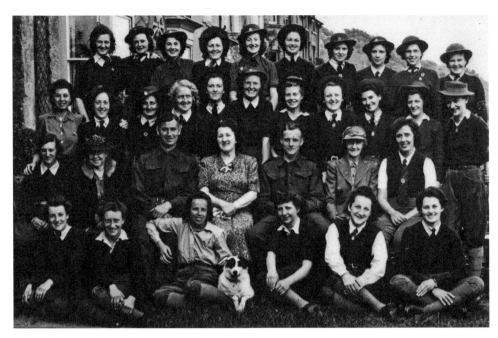

Land girls at the Cwlach Road rest home. Warden Mrs May Jones (centre) opened a hostel for bombed-out Londoners in May 1940. She came to Llandudno for six weeks but fell in love with the town and stayed for nearly three years, only resigning due to ill health. (Courtesy of Viv Hemmings)

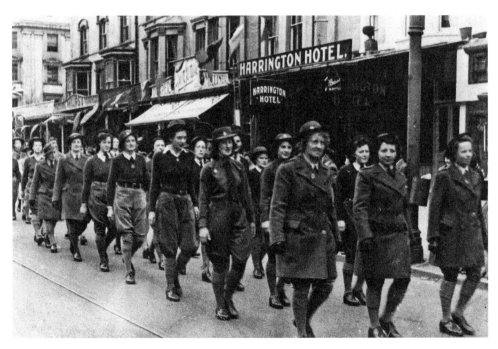

Land girls march down Mostyn Street. (Courtesy of Viv Hemmings)

The Women's Land Army was established in the First World War and reformed shortly before the outbreak of the Second World War to provide extra agricultural labour. They carried out a wide range of jobs, often labouring for long hours and under difficult conditions. In April 1944, the Women's Land Army opened their second holiday and rest home on Cwlach Road. Like the first hostel in Torquay, the Llandudno house was funded by an American charity, British War Relief Society of USA, and could accommodate fourteen women at a time. In the first year over 600 land girls spent a pleasant week enjoying the amenities of the hostel and town, and by the time it closed in September 1947 over 1,000 had stayed.

War Savings

Wars are exceptionally expensive and the government needed the help of the British people to pay for it. They implored people to invest in government accounts by buying War Bonds, Savings Bonds, Defence Bonds and Savings Certificates. Savings centres were opened including at St George's Place where a large 'totaliser' displayed the monies raised. The local organiser of the fundraising committee was retired Manchester bookkeeper Muriel Barnes. She had previously endured a double leg fracture after falling from a train at Llandudno railway station during the blackout. While people were encouraged to invest year-round, there was also an annual savings week with a specific target. The first of these was in November 1940 when a £100,000 target was set for 'War Weapons Week'. To assist the fundraising effort a captured Heinkel bomber was displayed at the 'tins' – the council football field on Conwy Road – with a charge of sixpence to view. Other highlights included a grand parade featuring personnel of the Royal Netherlands Army while three Hurricane fighters roared over the town. By the end of the week £205,925 had been raised, easily surpassing the target.

'Warship Week' took place in November 1941 with over £222,000 raised, enough to buy Royal Navy minesweeper HMS *Llandudno*. The money was raised through dances, collections and a parade on the first day of the fundraising week featuring one hundred sailors, resplendent in their uniforms and marching with bayonets fixed. Such was the success of Llandudno's Warship Week that a standard was raised outside the Town Hall to show that the town had invested the highest sum per head of population of any district in Caernarvonshire. After her launch, the ship was adopted by the town with gifts of comforts, knitted by local women, donated to the crew.

While there was much talk from civil leaders of how proud the residents would be when HMS *Llandudno* anchored in the bay, the warship never visited the town, instead spending much of the war in the waters around Iceland and the Denmark Straits. Undoubtedly the minesweeper's finest hour came on D-Day, 6 June 1944, when, under the command of Lieutenant Commander Frank Darnborough, she swept a channel allowing soldiers of the British 3rd Infantry Division to land on Sword beach as part of the Allied invasion.

Posters appeared across Llandudno advertising 'Warship Week' and businesses and householders were encouraged to decorate their premises with flags and bunting.

Plaque given to the people of Llandudno in recognition of their contribution during 'Warship Week'. (Courtesy of Llandudno Town Council)

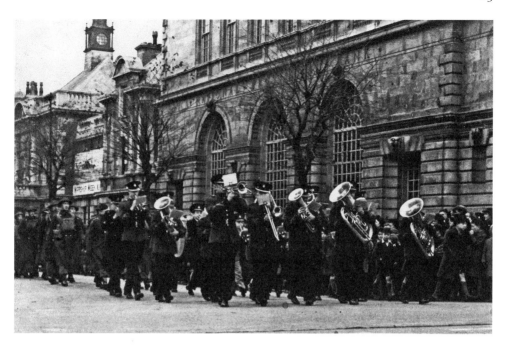

Above: Llandudno Town Band
leading the procession during
'Warship Week'. (Courtesy of
Susan Wolfendale)

Right: A special pin badge
was commissioned and sold
in aid of the National Savings
'Salute the Soldier' week.

A Bakelite plaque was awarded to the people of the town in recognition of the fundraising effort and displayed in the Town Hall. (Courtesy of Llandudno Town Council)

HMS *Llandudno* was not the first ship to bear the town's name; a merchant steamship did too. She was torpedoed by a German submarine off the Mediterranean island of Porquerolles in August 1917.

After 'Tanks for Attack' in 1942 and 'Wings for Victory' in 1943, 'Salute the Soldier Week' took place in the first week of June 1944, coinciding with the Normandy landings. For many the highlight of the week was the gunnery exhibition at the Crosville garage on Oxford Road and the sight of hundreds of American troops, billeted in Llandudno, marching down the promenade. Organisers sought to raise £200,000, enough to equip one battalion of infantrymen, one medical unit and one parachute battalion and again the public did not disappoint and nearly double the target was raised.

At the outbreak of the Second World War Llandudno had a population of 15,751 citizens. While this number increased significantly with the arrival of civil servants and members of the armed forces, it is still remarkable that the town raised nearly £4 million in war savings between 1940 and 1945. This equates to £144 million today.

Any Gum, Chum?

The availability of accommodation, already at a premium in wartime Llandudno with the influx of civil servants and artillerymen in 1940, became critical with the arrival of the US Army medical corps. Arriving in February 1944, thousands of American soldiers passed through Llandudno from the build up to D-Day until the end of the war in Europe in May 1945. 'Snowdrops' – American military

police – became a familiar sight going from house to house seeking rooms for their charges. Some locals willingly gave up their bedrooms, choosing to sleep in the garden shed to accommodate the GIs and earn a few extra shillings in the process. Many families befriended American servicemen, the soldiers invited for Sunday lunch and to feel part of a family while the householders were pleased when their guests brought gifts of food, sweets and silk stockings, all in short supply in ration-hit Britain. One senior American army officer described how the women of Llandudno had 'been more like mothers than landladies to us' and long after the war many kept up correspondence. Some prominent properties were requisitioned for the medics: the Drummond Hotel in Trinity Square was used by senior officers, the Marlborough Hotel billeted female officers and Nissen huts were erected on Gloddaeth Avenue and Argyle Road as cookhouses for other ranks. After the war, one of these corrugated buildings was utilised as Llandudno's first Welsh school, others as Llandudno Catering College. The GIs trained on the promenade and on John Bright Grammar School playing fields where the unfamiliar sport of baseball was introduced to the populace. In May 1944, US soldiers became the first foreign troops to join the annual civic parade.

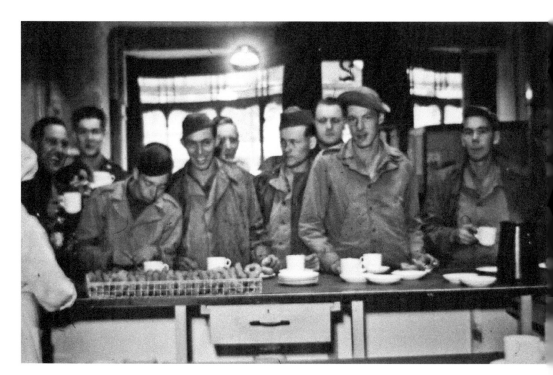

A rest and relaxation centre – a 'Donut Dugout' – was established in Vaughan Street. Here US soldiers could socialise, get a taste of home and browse through the latest American periodicals. (Courtesy of Conwy Archives Service)

Many of the American army medics billeted in Llandudno were women including Ruth Cunningham (on the left) who, along with another American nurse, was billeted with the Wynne family on Bryniau Road. (Courtesy of Carol Wynne)

The Americans, with their smart uniforms and bulging wallets, were universally liked, especially by the girls, and romances blossomed. A small number married before following their new loves to a new land, when US authorities relaxed the immigration quota in 1946, allowing them into the country. Among the 70,000 brides were sisters Dilys and Betty Roberts, of Alexandra Road, who married in a double ceremony at Holy Trinity Church to lifelong friends Sergeants Paul Tolstoy and Charles Wahchnowski of Pennsylvania.

Black American troops were segregated from their white contemporaries and billeted around the Ministry of Food cold storage depot in Llandudno Junction. One incident in summer 1944 stuck in the memory of a Llandudno man all his life. John Jones was waiting for his cousin to alight the bus outside 'The Clock' public house on Mostyn Street (now the Halifax Building Society) when a fight broke out between white American servicemen. Immediately a jeep pulled up, laden with American military police, who grabbed a black GI and started to truncheon him without mercy, even though he had no connection to the original fracas.

Salvage

There was a drive to collect iron and steel. A dump was opened at the rear of the Town Hall and many tons were amassed including a disused locomotive and 30 feet of track from the abandoned quarry at Llangwstenin. Fifty tip wagons and wheels, sheathed with iron plates, as well as 20 tons of steel girders were found at the Little Orme limestone pits and these too were sent to be transformed into tanks and other weapons of war. Gates and railings were not exempt either. In 1943 the Ministry of Works ordered all councils to survey iron railings in their area. The borough surveyor listed every railing, gate and set of gate posts in the district before notifying householders that the railings would be taken. A Liverpool company, Molyneux Ltd, was awarded the contract and armed with oxy-acetylene torches started to remove the ornate ironwork from Victorian Llandudno. Owners of railings of 'artistic or historic merit' were permitted to lodge an appeal but these were rarely upheld.

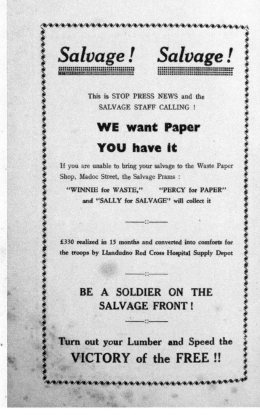

SAVE Your SALVAGE
AND
HELP TO SHORTEN THE WAR!

It is proposed this month (April, 1942) and onwards to make a special effort in this town in the collection of Salvage of all kinds. Your co-operation, therefore, in this collection is particularly desired and will be much appreciated.

The following commodities are urgently needed for the intensification of the war effort :—

GENERAL SCRAP IRON
TINS
WASTE PAPER
BONES
RAGS
RUBBER

For general scrap iron, particularly the heavier materials, the Council has provided dumps in different parts of the District. These dumps are labelled with the notice " Llandudno U.D.C., Scrap Iron Salvage Dump."

For the other five commodities special dumps are available at the Council Yard, George Street, but you are reminded that for the collection of these general salvage materials facilities are also in existence on the refuse collection vehicles.

If you are in any difficulty regarding collections you should immediately get in touch with the Salvage Steward for the particular street or area concerned.

The Salvage Steward for your particular area is :—

Salvage Department,
 Town Hall, Telephone 6281.

Salvage! Salvage!

This is STOP PRESS NEWS and the SALVAGE STAFF CALLING !

WE want Paper
YOU have it

If you are unable to bring your salvage to the Waste Paper Shop, Madoc Street, the Salvage Prams :

"WINNIE for WASTE," "PERCY for PAPER" and "SALLY for SALVAGE" will collect it

£330 realized in 15 months and converted into comforts for the troops by Llandudno Red Cross Hospital Supply Depot

BE A SOLDIER ON THE SALVAGE FRONT !

Turn out your Lumber and Speed the
VICTORY of the FREE !!

The government encouraged the public to collect as much useful waste material as possible to aid the war effort. Industrial demand for materials increased greatly but supply was considerably reduced due to the sizeable losses of merchant vessels in the Atlantic. The residents of Llandudno were urged to save paper, rags, bones, rubber, all types of metal and even string.

It was an offence to destroy or throw away any paper or cardboard. In July 1940 a scrap paper depot was opened at this former butcher's shop on the corner of Albert and Madoc Streets. On average 2 tons of paper was collected every week by volunteers with their trusty perambulators: Winnie for Waste, Percy for Paper and Sally for Salvage.

The gates of Tan-y-bryn School in Craig-y-don, erected in honour of the pupils killed in the First World War, were removed as part of the salvage campaign and replaced with a commemorative plaque mounted on the gatepost.

Victory

On 8 May 1945, crowds, draped in the flags of the victorious nations, inundated the Town Hall and listened intently as Winston Churchill broadcast live to the nation from the balcony of the Ministry of Health building in London. The war in Europe was over. As a victory peal rang out from Holy Trinity Church, the town bandsmen struck up, playing the national anthems of the Allies. With the formalities concluded the band played a repertoire of popular tunes and marched to the promenade followed by rejoicing residents. The singing and dancing continued late into the night and bonfires were lit on the beach and surrounding hills, fuelled by people collecting rubbish from the rear of shops on Mostyn Street.

In the subsequent weeks, street parties were organised. Primarily for the younger members of the community, they were an opportunity to don fancy dress while ration coupons were pooled to put on a spread. These celebrations were tinged with sadness as often the children had lost fathers, brothers or uncles in the war.

Three months after the war ended in Europe, Victory over Japan Day marked the end of the Second World War. It was not celebrated as frenetically as VE Day but still was an opportunity for another bonfire and an impromptu procession. Banging tin cans, revellers marched down Gloddaeth Avenue to West Shore to see an effigy of Hideki Tojo, the Japanese prime minister, burn, while searchlights from the Coast Artillery School illuminated the night sky.

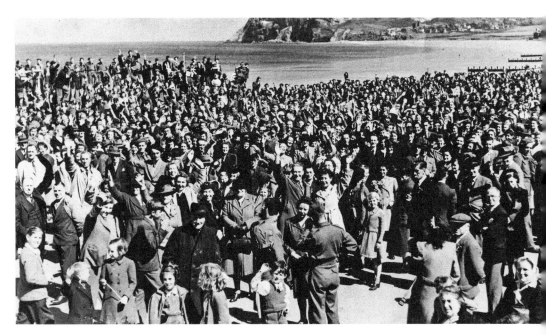

Thousands of people gathered on the promenade at the announcement that the war in Europe was over, and partied into the night. (Courtesy of Terry Bond)

Children of Taliesin and Chapel Streets enjoying a VE Day party in May 1945. (Courtesy of David Kyffin)

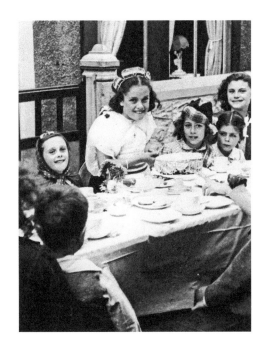

Victory Queen Patricia Meredith lost her father in February 1943. Frank Meredith was with the local battery of the Royal Artillery when he was mortally wounded by a Luftwaffe dive bomber in North Africa. (Courtesy of Joyce Roberts)

In 1957, twelve years to the day after the end of the war in Europe, four bronze plaques were unveiled on the war memorial to commemorate the 124 men from Llandudno killed. Chairman of the council, Charlie Payne, led the ceremony, having served in the RAF during the war and being Mentioned in Dispatches three times.

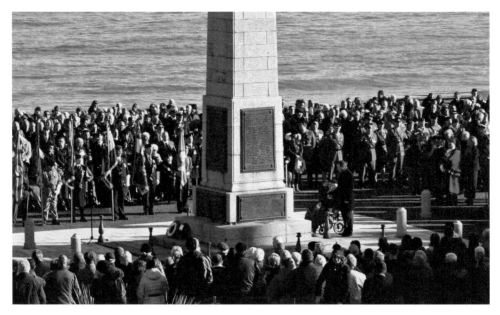

Today, the people of Llandudno continue to remember all those from the town who fell in war with hundreds gathering at the war memorial for a service on Remembrance Sunday.

Elsewhere in Llandudno, volunteers annually place poppies on properties where servicemen who went away to war but did not return home once lived. On Bridge Road a poppy commemorates Corporal Redvers Evans, who served with the 6th Battalion of the Royal Welsh Fusiliers during the Second World War.

On 24 September 1944, Evans' battalion was engaged in fierce fighting around the Dutch village of Reusel. Evans single-handedly took out a German machine-gun post, firing his Bren gun from the hip and wiping out the enemy. A second German machine-gun post was holding up the Allied advance, and with 'great courage and initiative', the Llandudno lad crawled forward, knocking that one out too. For his bravery, Redvers was awarded the Military Medal. Sadly, Redvers Evans was mortally wounded in March 1945, before he could collect his medal. Instead, his parents, brother and sister collected his award from King George VI at a ceremony at Buckingham Palace, weeks after his death. Redvers is buried at Mook War Cemetery, Netherlands. He was just nineteen years old. (Courtesy of Sharon Walters, Joan Williamson)

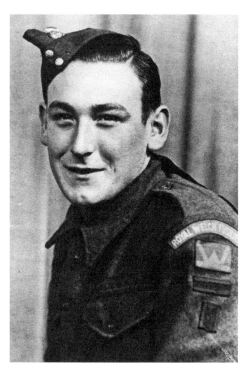

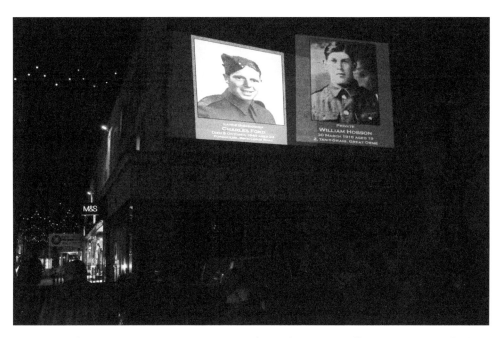

A seemingly unique commemoration takes place annually the evening before Remembrance Sunday, when the portraits of more than 300 servicemen listed on Llandudno's war memorial are projected onto the wall of Marks & Spencer on the main shopping street.

Acknowledgements

We offer a huge thank you to those who kindly gave us access to invaluable information, fascinating images and other much-appreciated assistance:

David Atkinson, Robert Barnsdale, Terry Bond, Jerry Bone, Jennifer Britton, Lalita Carlton-Jones, Jacqueline and Jason Codman-Millband, Michael Dunn, Charles Eaves at All Our Yesterdays, Cllr Philip Evans and Llandudno Town Council, Kevin Griffiths, Valerie Hailwood, Viv Hemmings, John Holmes, Bob Hughes, Catherine Hughes, Julian Hughes, Christine Jones, John Jones, Margaret Verena Jones, Ronnie Jones, David Kyffin, Tony Marsden, Margaret Meddings, Rob Mitchell and the Baytree Hotel, Mary Oliver, Idris Owen, Joyce Roberts, Mike Sargent, Netta Shirley, Elizabeth Turner, Sharon Walters, Susan Wolfendale and Carol Wynne.

Blind Veterans UK, Conwy Archives Service, Great Orme Mines Ltd, Gwynedd Archaeological Trust, National Museum of Wales, and National Portrait Gallery.